DRAW 50

DRAW THE DRAW 50 WAY

How to Draw Cats, Puppies, Horses, Buildings, Birds, Aliens, Boats, Trains, and Everything Else Under the Sun

BOOKS IN THIS SERIES

- *Draw 50 Airplanes, Aircraft, and Spacecraft*
- *Draw 50 Aliens*
- *Draw 50 Animal 'Toons*
- *Draw 50 Animals*
- *Draw 50 Athletes*
- *Draw 50 Baby Animals*
- *Draw 50 Beasties*
- *Draw 50 Birds*
- *Draw 50 Boats, Ships, Trucks, and Trains*
- *Draw 50 Buildings and Other Structures*
- *Draw 50 Cars, Trucks, and Motorcycles*
- *Draw 50 Cats*
- *Draw 50 Creepy Crawlies*
- *Draw 50 Dinosaurs and Other Prehistoric Animals*
- *Draw 50 Dogs*
- *Draw 50 Endangered Animals*
- *Draw 50 Famous Cartoons*
- *Draw 50 Flowers, Trees, and Other Plants*
- *Draw 50 Horses*
- *Draw 50 Magical Creatures*
- *Draw 50 Monsters*
- *Draw 50 People*
- *Draw 50 Princesses*
- *Draw 50 Sharks, Whales, and Other Sea Creatures*
- *Draw 50 Vehicles*
- *Draw the Draw 50 Way*

DRAW 50

DRAW THE
DRAW 50 WAY

*How to Draw Cats, Puppies, Horses,
Buildings, Birds, Aliens, Boats, Trains,
and Everything Else Under the Sun*

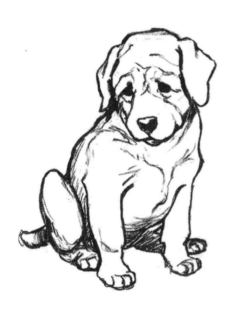

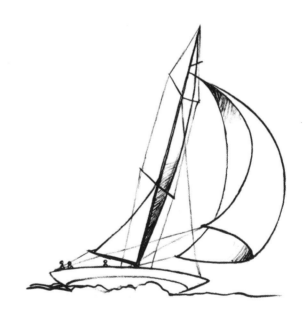

LEE J. AMES

WATSON-GUPTILL PUBLICATIONS
Berkeley

Published in the United States by Watson-Guptill Publications, an imprint
of the Crown Publishing Group, a division of Random House LLC,
a Penguin Random House Company, New York.
www.crownpublishing.com
www.watsonguptill.com

WATSON-GUPTILL and the WG and Horse designs are registered
trademarks of Random House LLC.

Originally published in trade paperback in the United States by
Broadway Books, a division of Random House LLC, New York, in 2005.

Library of Congress Cataloging-in-Publication Data

Ames, Lee J.
 The draw 50 way: how to draw cats, puppies, horses, buildings, birds,
aliens, trains, and everything under the sun / Lee J. Ames

 p. cm.
1. Drawing—Technique. I. Title: Draw fifty way. II. Title: How to draw cats,
puppies, horses, buildings, birds, aleins, trains, and everything under the
sun. III. Title.
NC730.A567 2005
741/2—dc22

 2004058579

ISBN 978-0-8230-8580-4
eISBN 978-0-7704-3296-6

Printed in the United States of America

10 9 8 7 6

2014 Watson-Guptill Edition

To Jocelyn with love, always

Author's Note

If we taught children to speak, they'd never learn.
—William Hull

Thirty or forty years ago, I read this quote. It stuck with me because I believe we often learn best through imitation. In many of my books I have advised that mimicry is prerequisite to creativity. It's wonderfully effective to imitate, copy, or trace what others have done in order to develop one's own tools for drawing before attempting to produce something original.

Anyone who is attracted to the *Draw 50* books has probably been interested in drawing to begin with and likely has been drawing for some time. The *Draw 50*s provide a method, a method of conceiving, observing, developing, constructing, improving, and finishing a subject.

I started "drawing 50" more than thirty years ago with *Draw 50 Animals*. Now, there are twenty-seven titles in the *Draw 50* series, and each of them walks you through a step-by-step way to draw a particular subject from boats to beasties to cats to dinosaurs. The *Draw 50 Way* brings together some of my favorite drawings from these books, so you can get a sense of how to draw anything from a cow to a Viking ship. You'll notice that each drawing here is identified by the subject and by the *Draw 50* book it came from, so if you find yourself wanting more, you'll know where to look.

I hope you will enjoy drawing as much as I have for the past eighty years!

Lee J. Ames, BTG

To the Reader

Before you begin drawing, here are some tips on how to use and enjoy this book.

When you start working, use clean white bond paper or drawing paper and a pencil with a moderately soft lead (HB or No. 2). Have a kneaded eraser on hand (available at art supply stores). Choose any one of the subjects in the book that you want to draw, and then very lightly and very carefully sketch out the first step. As you do, study the finished step of your chosen drawing to sense how your first step will fit in. Make sure that the size of the first step is not so small that the final drawing will be tiny, or so large that you won't be able to fit the finished drawing on the paper. Then, also very lightly and very carefully, sketch out the second step. As you go along, step by step, study not only the lines but also the size of the spaces between the lines. Remember, the first steps must be constructed with the greatest care. A wrongly placed stroke could throw the whole drawing off!

As you work, it is a good idea to have a mirror available. Holding your sketch up to the mirror from time to time can show you distortions you might not see otherwise.

As you are adding the steps, you may discover that they are becoming too dark. Here's where the kneaded eraser becomes particularly useful. You can lighten the darker penciling by strongly pressing the clay-like eraser onto the dark areas.

When you've put it all together and gotten to the last step, finish the drawing firmly with dark accurate strokes. There is your finished drawing. However, if you want to further finish the drawing with India ink, applied with a pen or fine brush, you can clean out all of the penciling with a kneaded eraser after the ink completely dries.

Remember, if your first attempts do not turn out too well, it's important to keep trying. Practice and patience do indeed help. I would like you to know that on occasion when I have used the steps for a drawing from one of my own books, it has taken me as much as an hour or two to bring it to a finish.

So have fun learning to draw . . . *The Draw 50 Way.*

THE DRAW 50 WAY

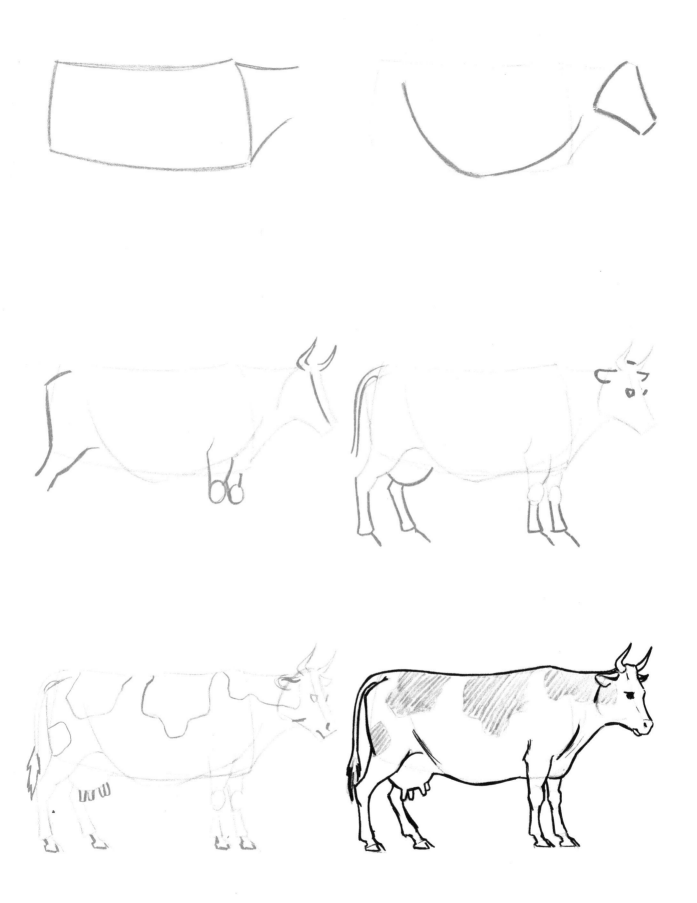

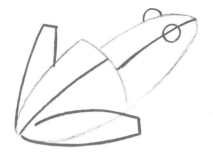

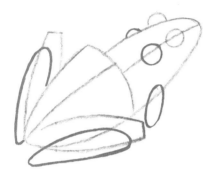

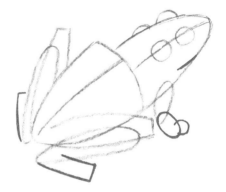

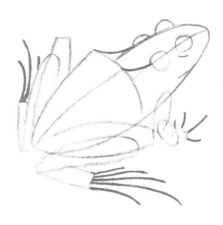

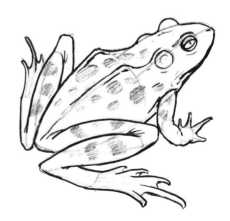

FROG
Draw 50 Animals

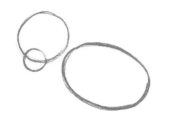
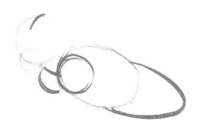
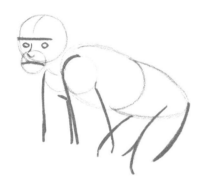
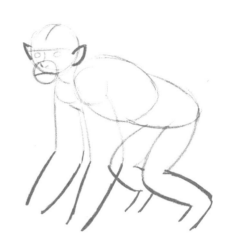
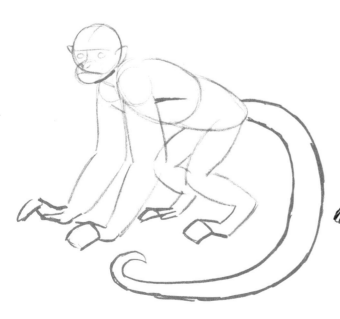
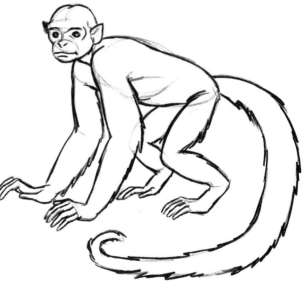

MONKEY
Draw 50 Animals

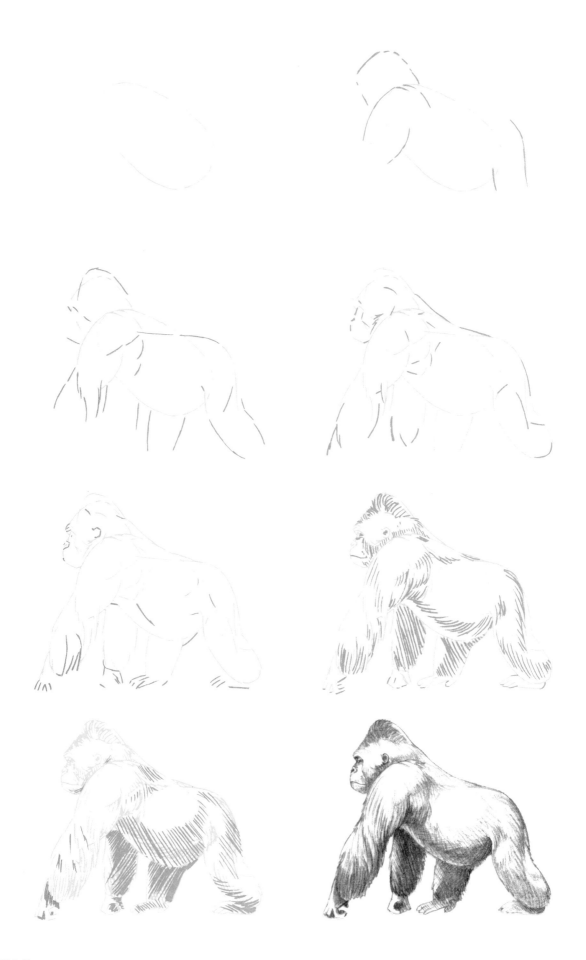

GORILLA
Draw 50 Endangered Animals

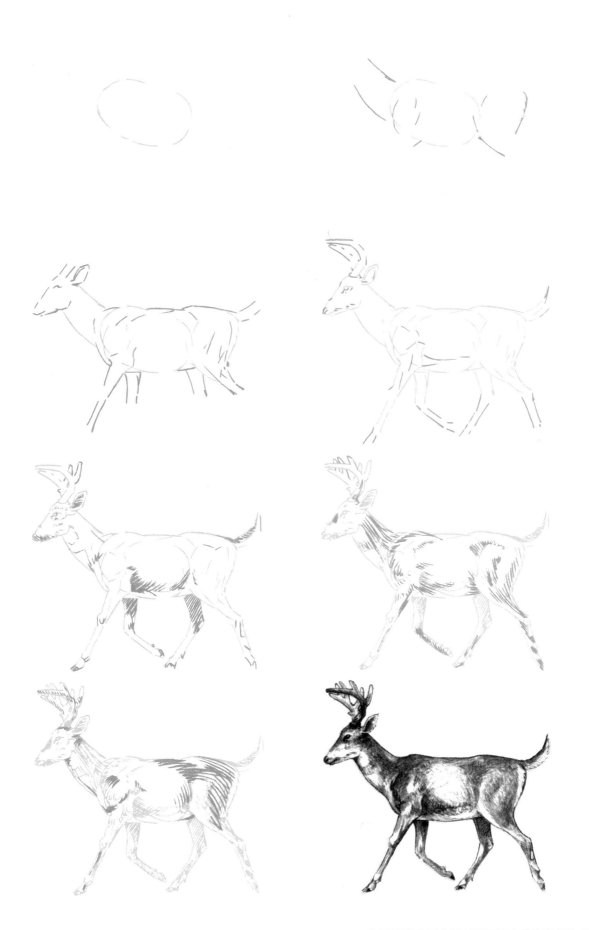

COLUMBIAN WHITE-TAILED DEER
Draw 50 Endangered Animals

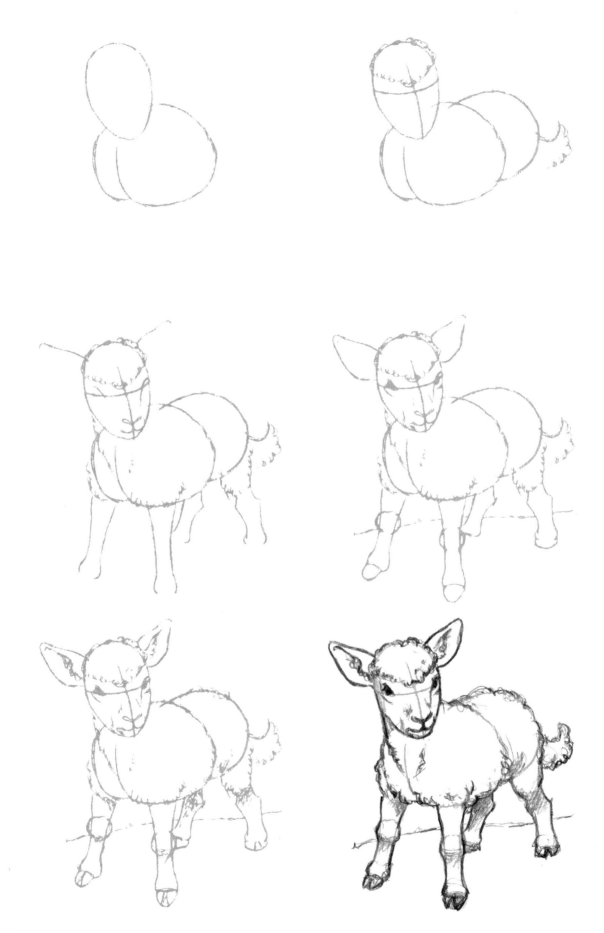

LAMB

Draw 50 Baby Animals

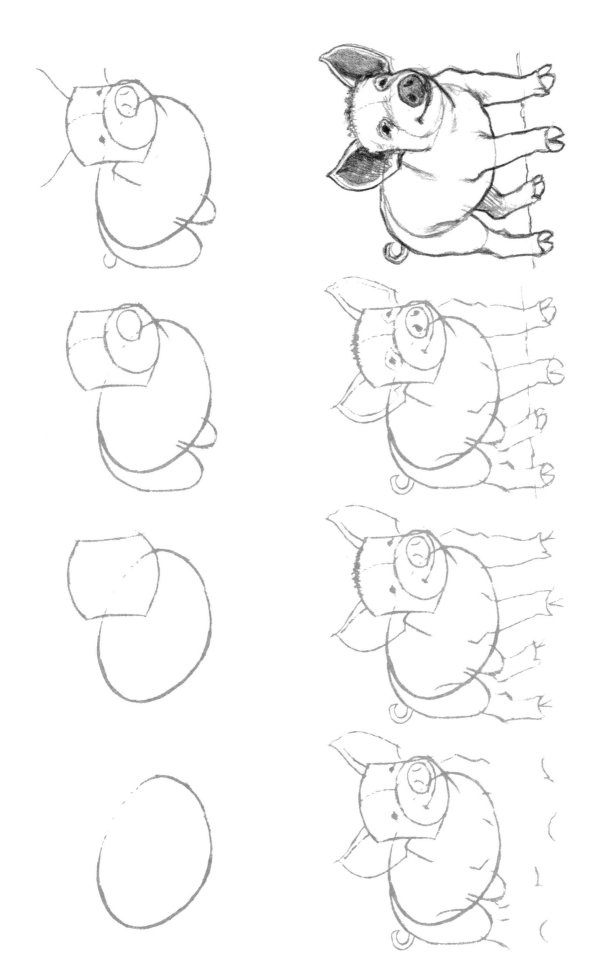

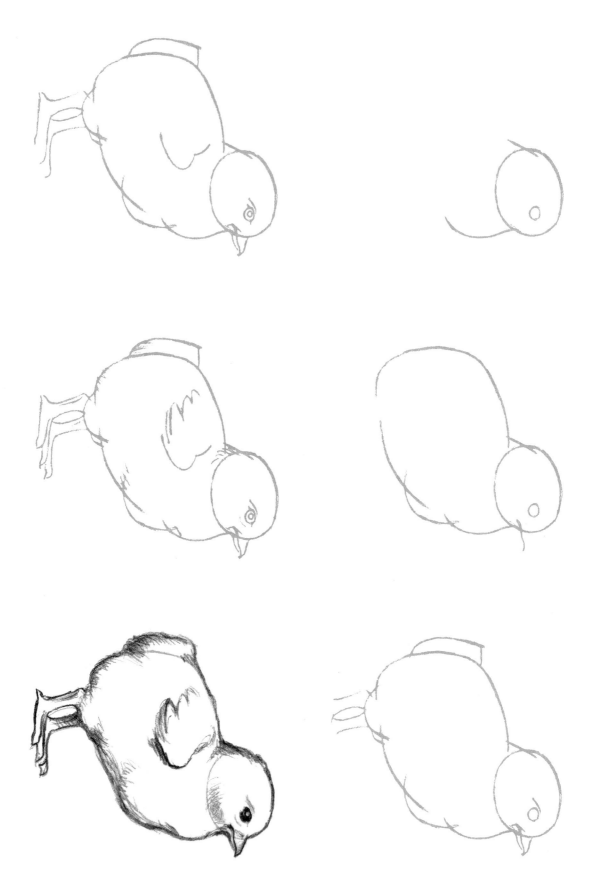

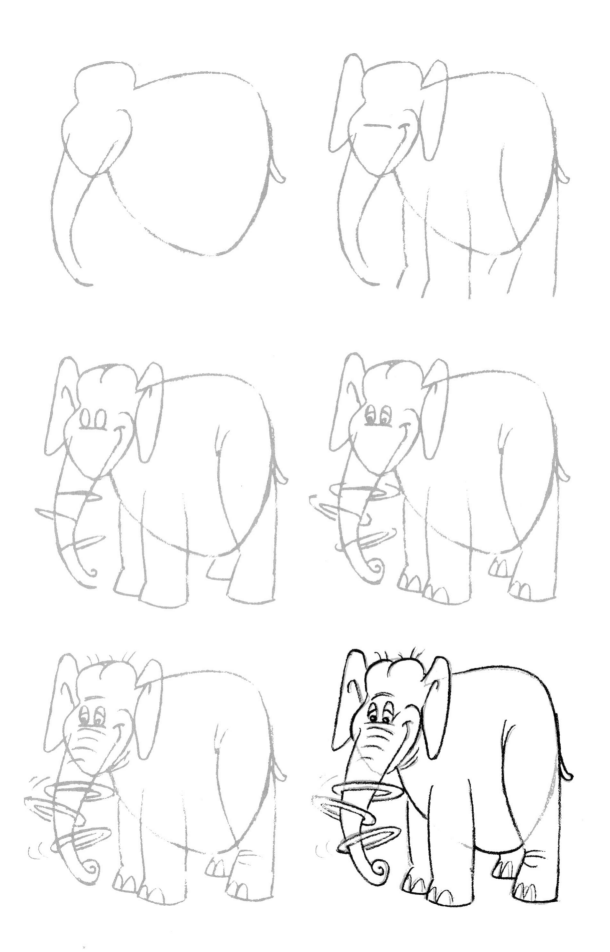

HOOP SPINNER L.F. AUNT

Draw 50 Animal 'Toons

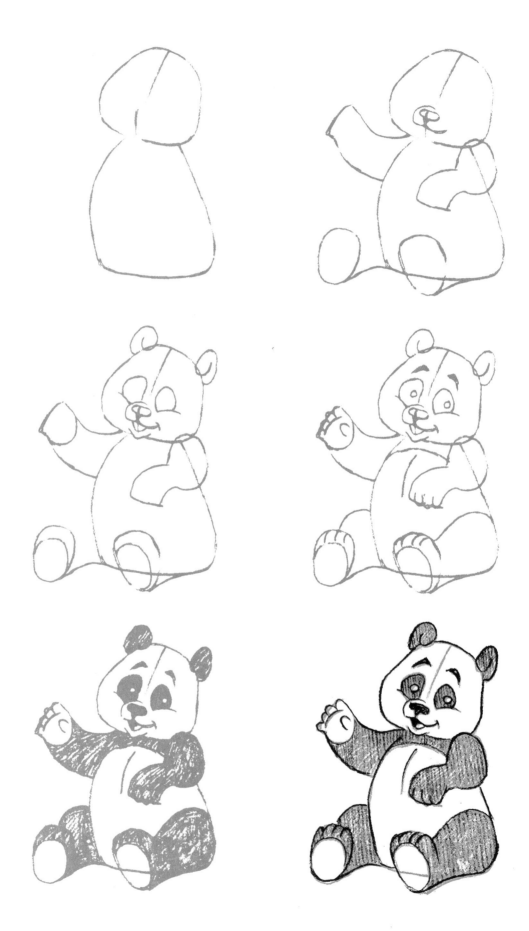

AMANDA PANDA

Draw 50 Animal 'Toons

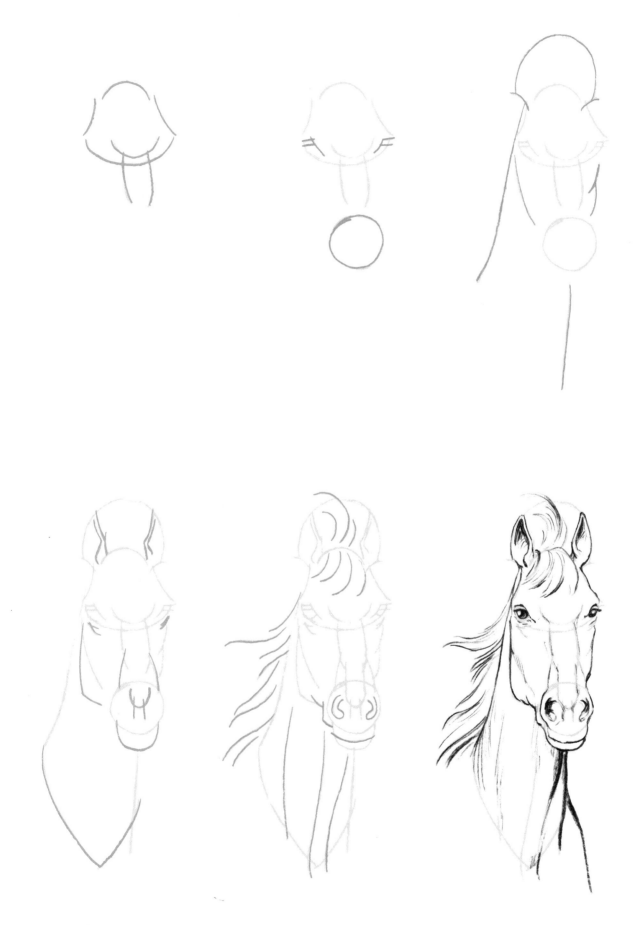

HORSE—FRONTAL VIEW
Draw 50 Horses

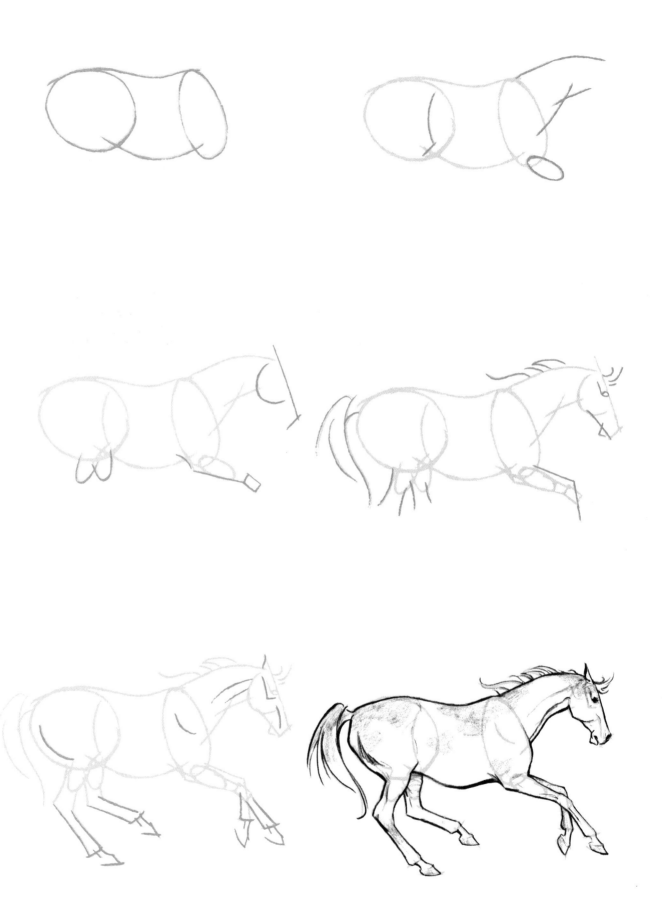

PINTO
Draw 50 Horses

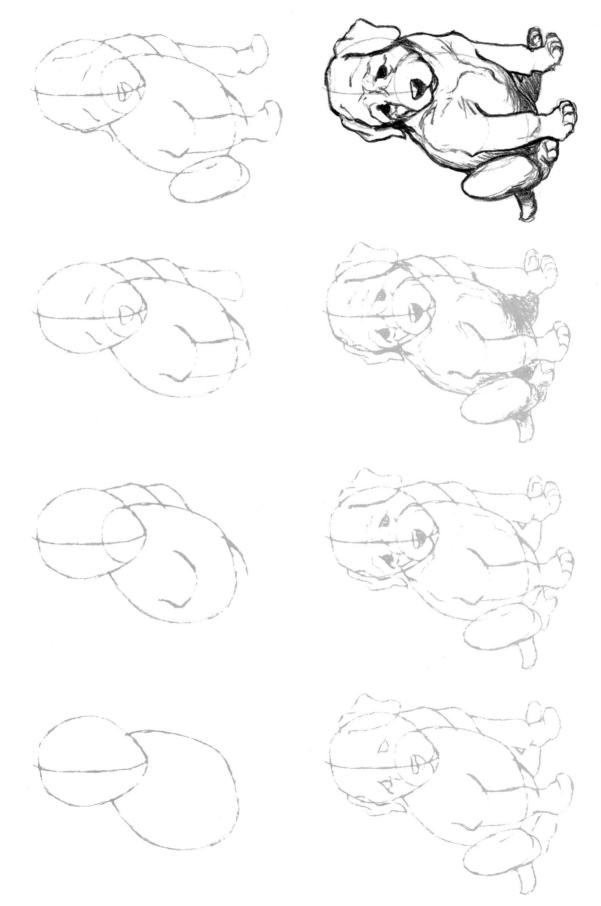

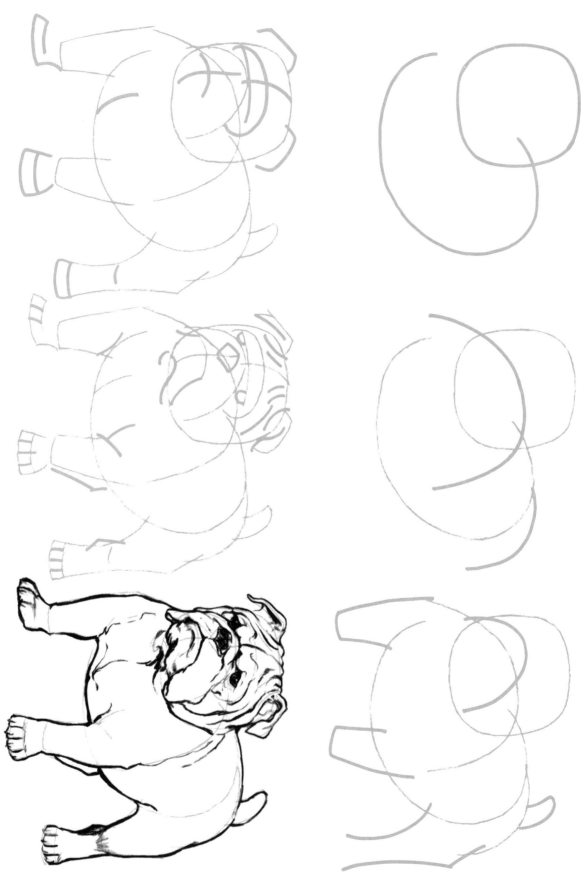

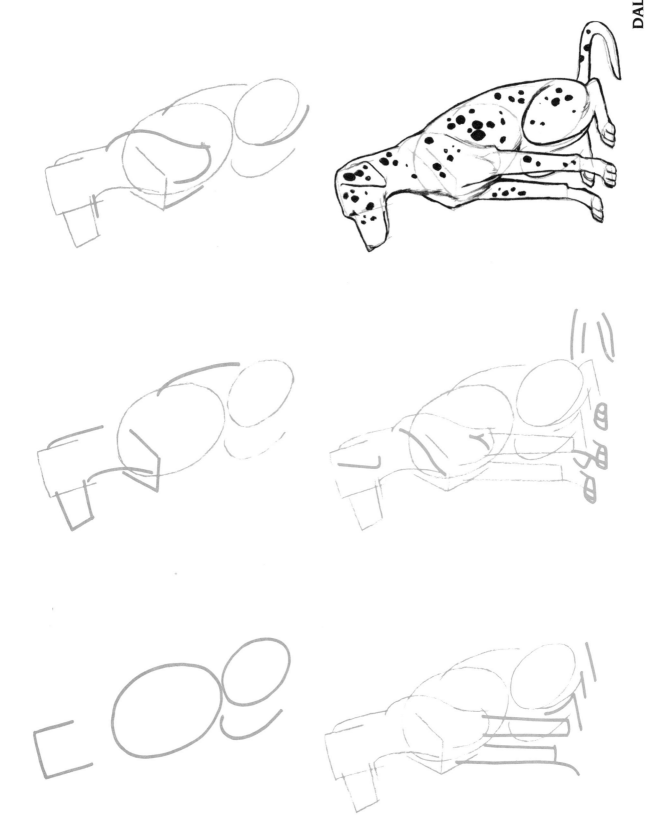

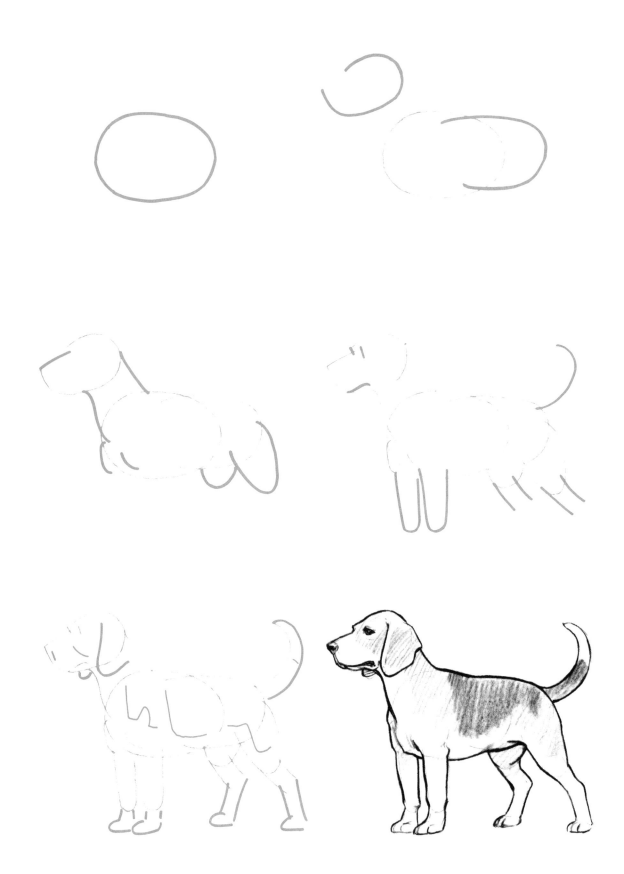

BEAGLE
Draw 50 Dogs

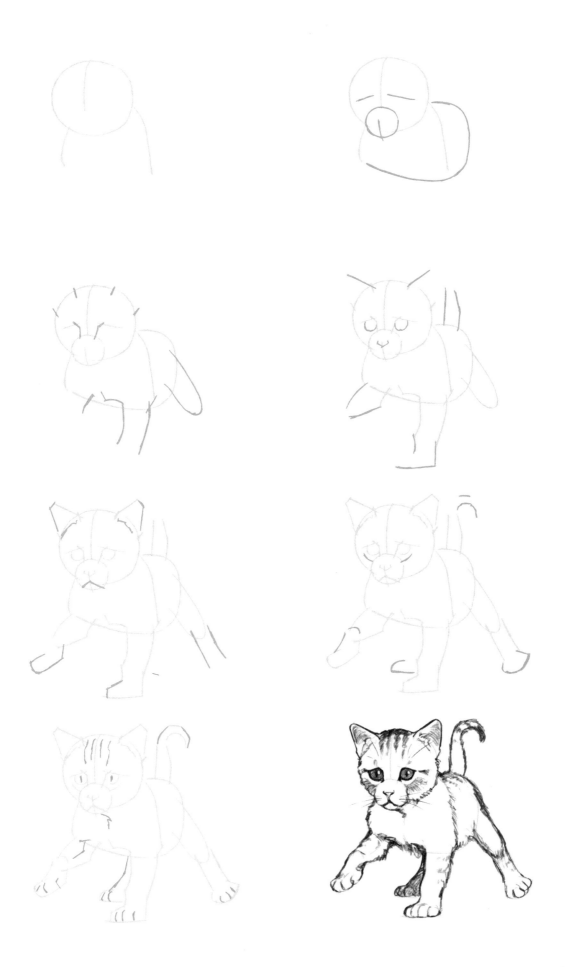

KITTEN
Draw 50 Cats

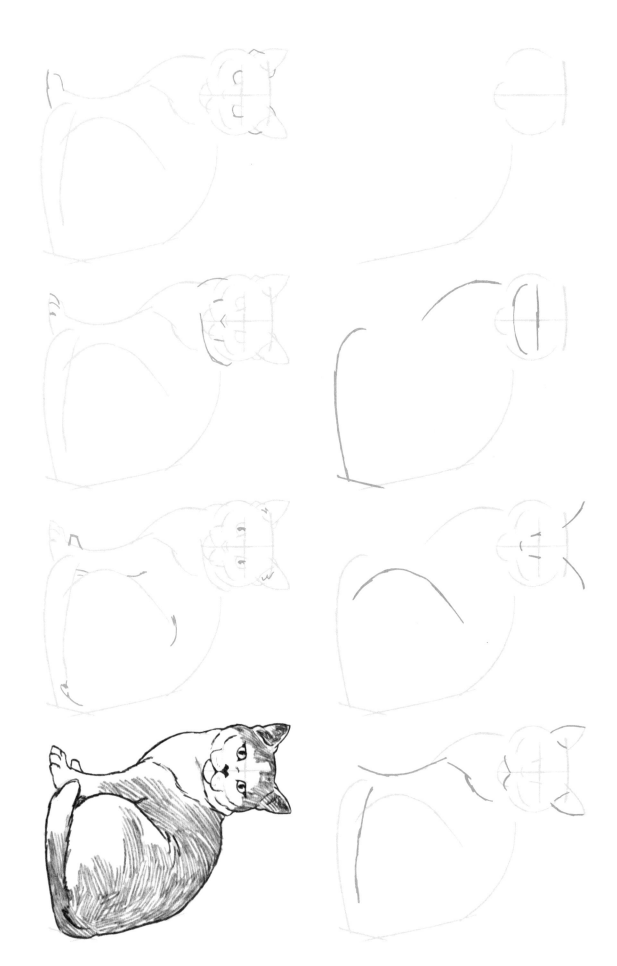

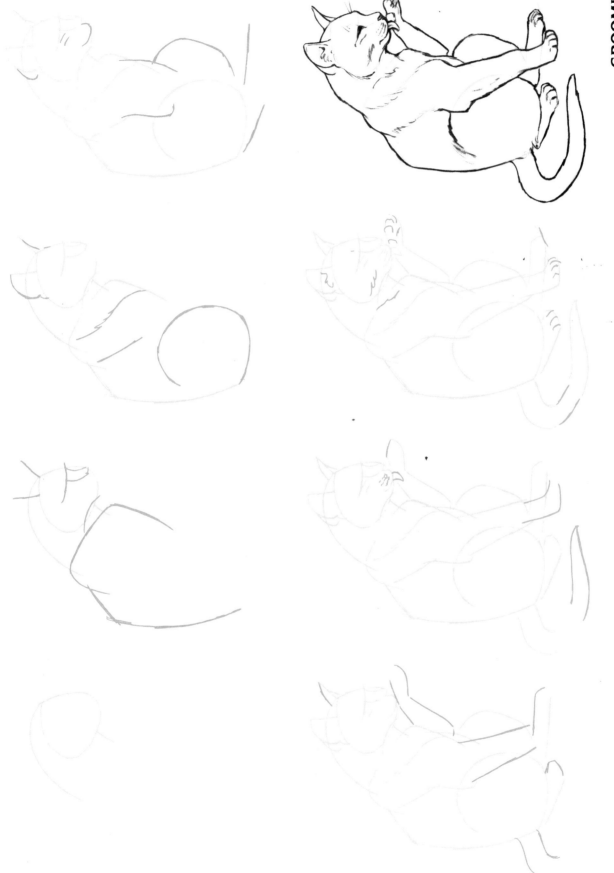

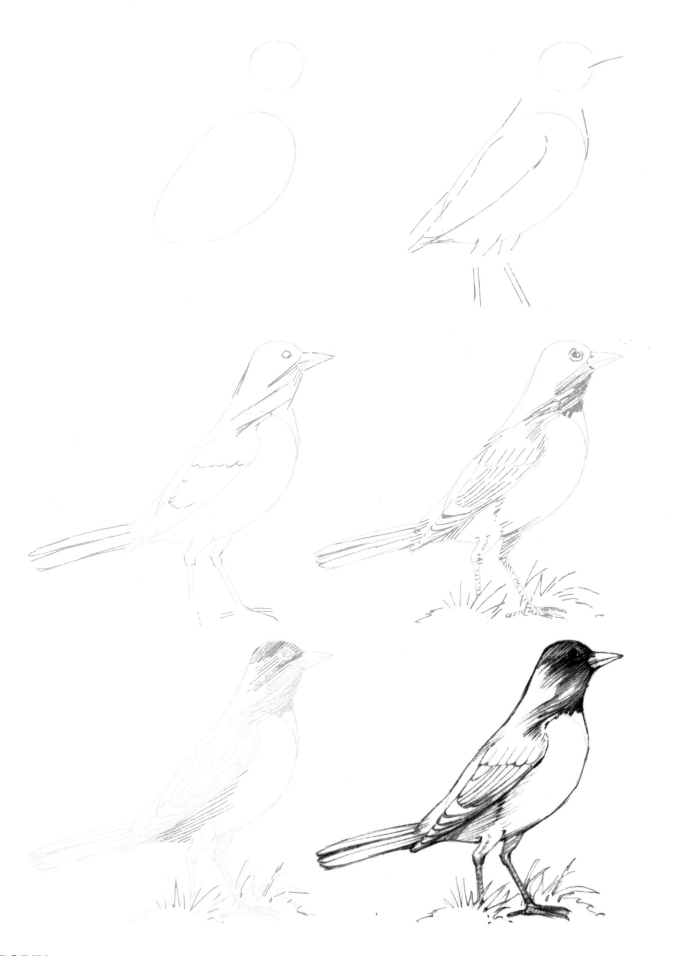

ROBIN

Draw 50 Birds

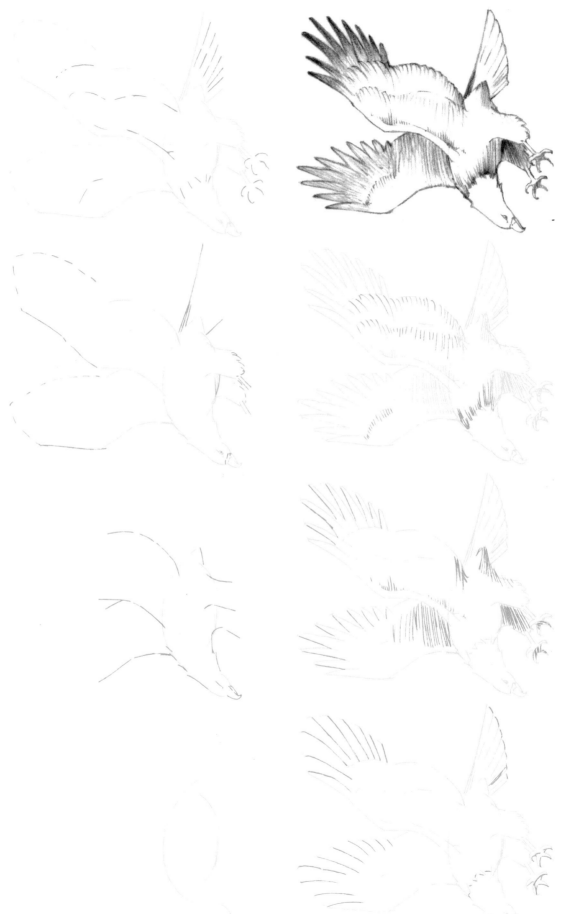

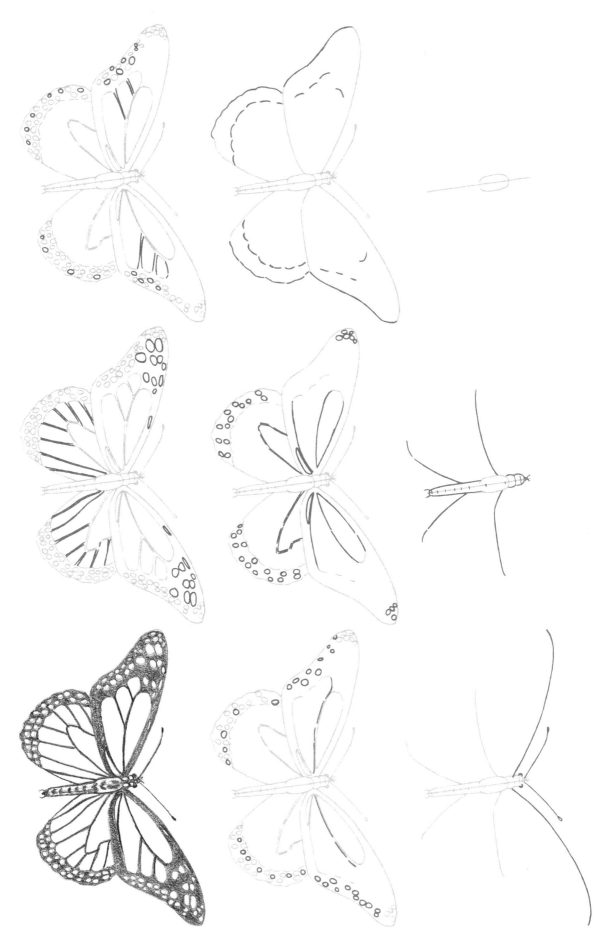

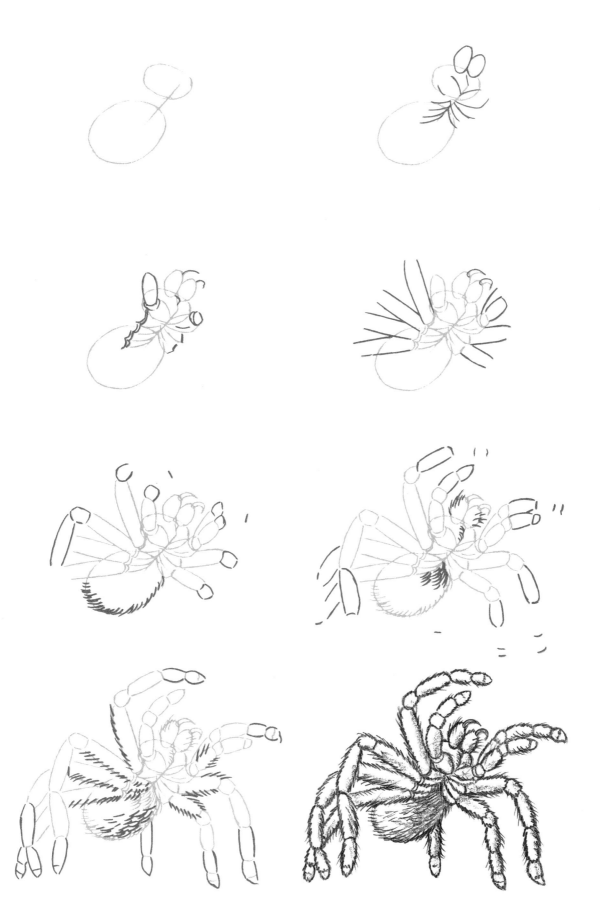

TARANTULA
Draw 50 Creepy Crawlies

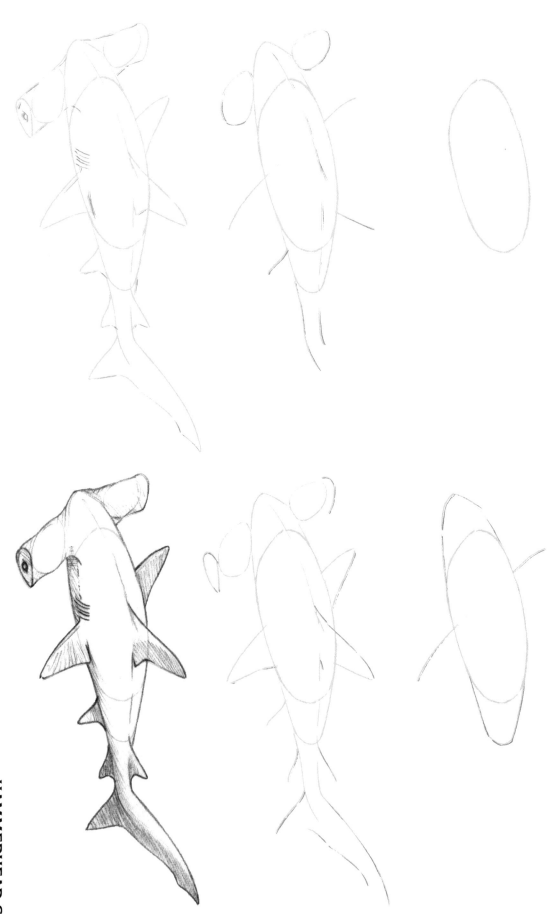

HAMMERHEAD SHARK

Draw 50 Sharks, Whales, and Other Sea Creatures

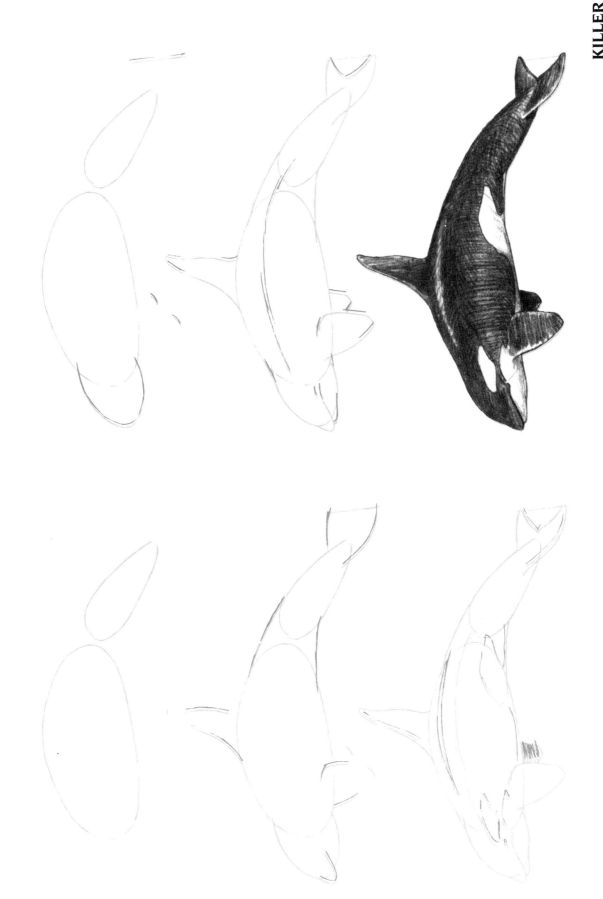

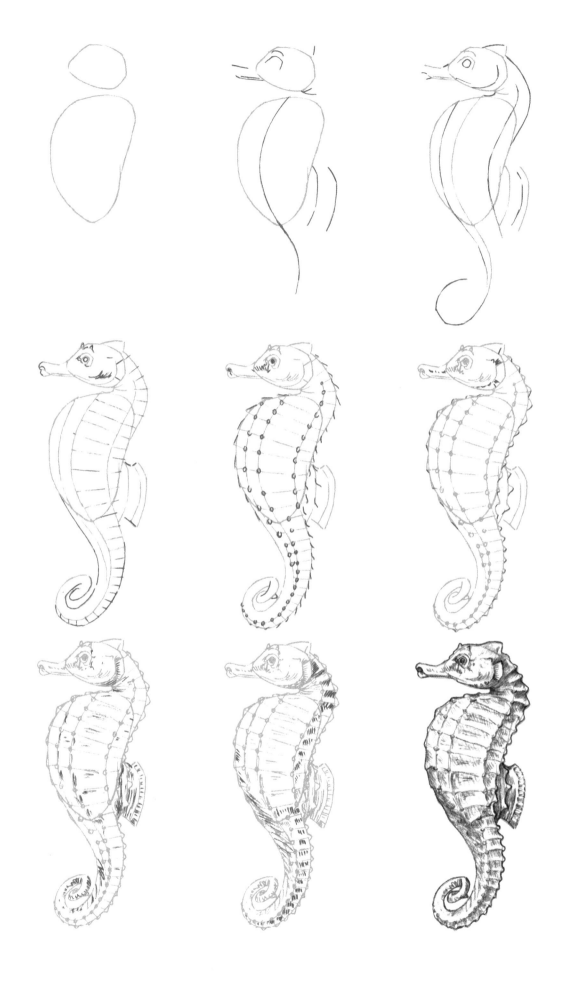

SEAHORSE

Draw 50 Sharks, Whales, and Other Sea Creatures

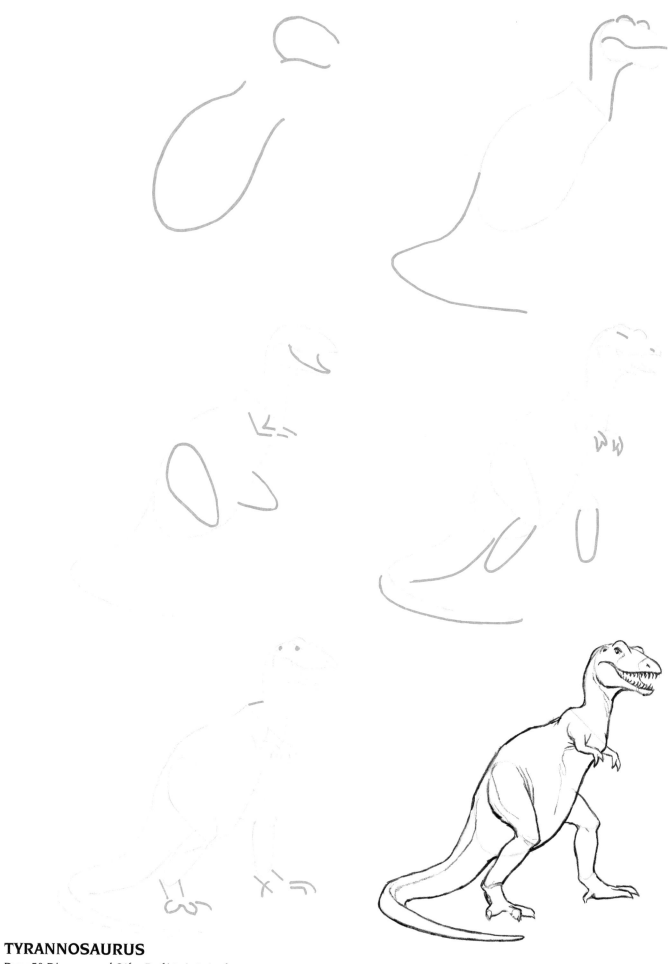

TYRANNOSAURUS

Draw 50 Dinosaurs and Other Prehistoric Animals

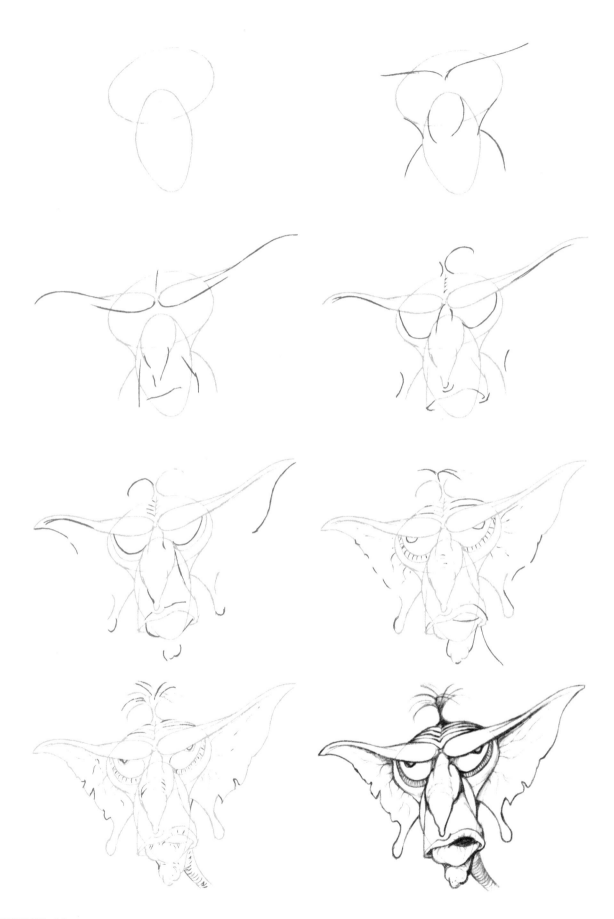

IMP EARIE AL

Draw 50 Beasties and Yugglies and Turnover Uglies and Things That Go Bump in the Night

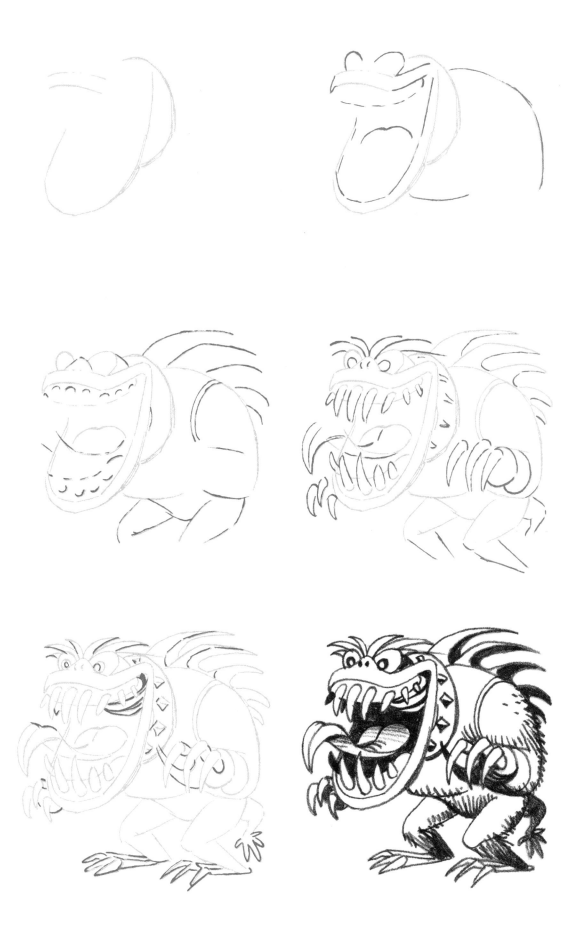

GABBA GHOUL

Draw 50 Aliens, UFOs, Galaxy Ghouls, Milky Way Marauders, and Other Extraterrestrial Creatures

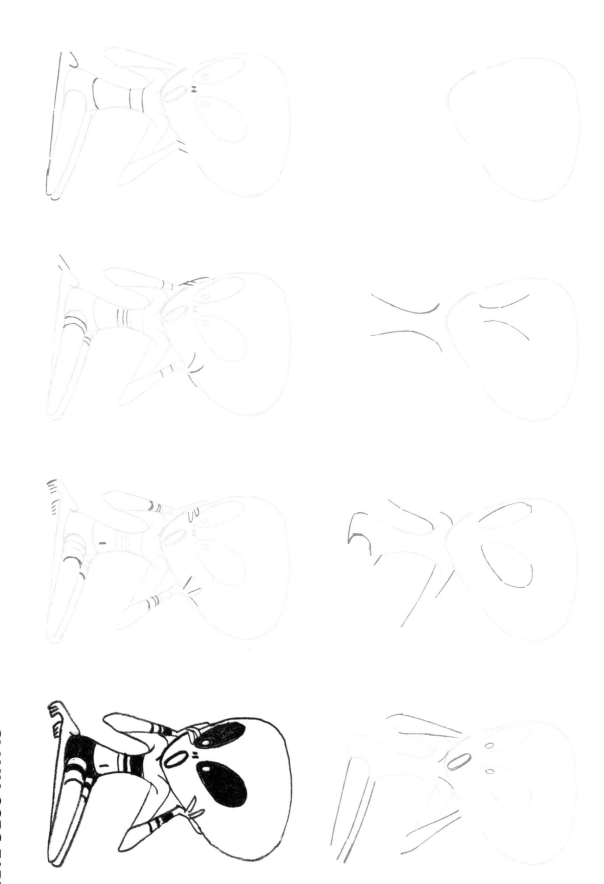

Draw 50 Aliens, UFOs, Galaxy Ghouls, Milky Way Marauders, and Other Extraterrestrial Creatures

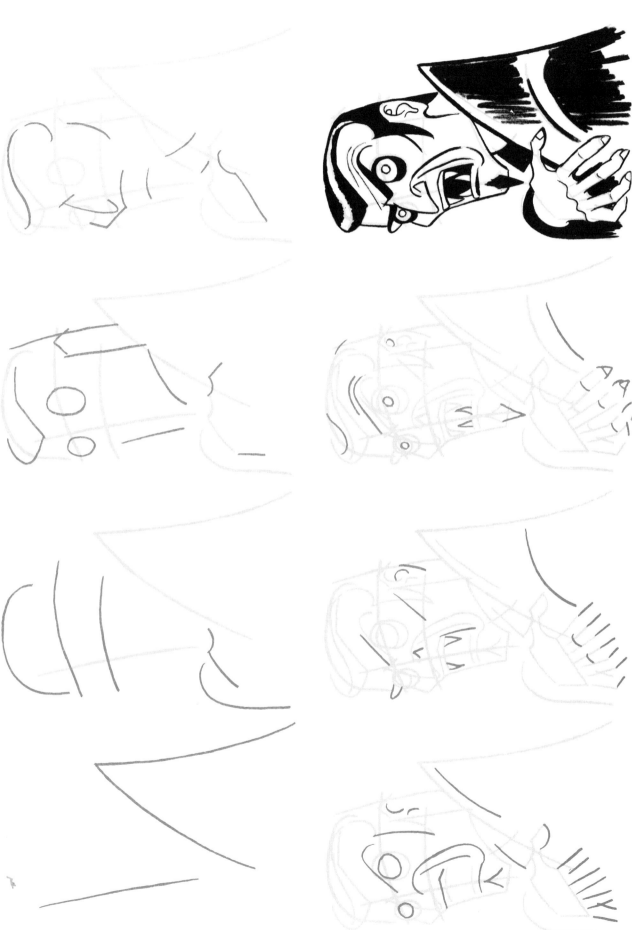

Draw 50 Monsters, Creeps, Superheroes, Demons, Dragons, Nerds, Dirts, Ghouls, Giants, Vampires, Zombies, and Other Curiosa

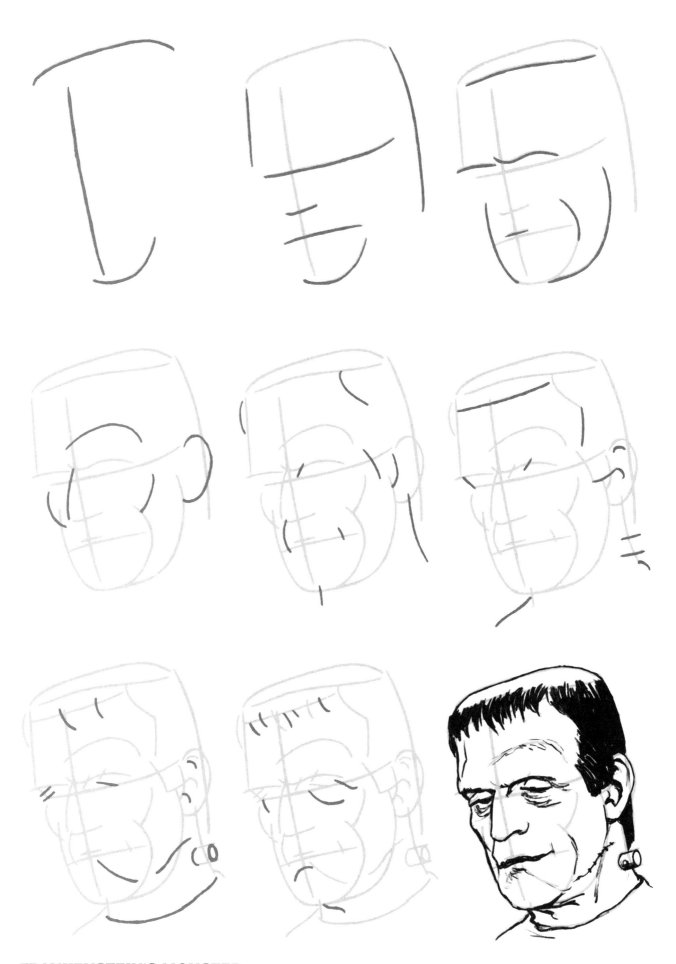

FRANKENSTEIN'S MONSTER

Draw 50 Monsters, Creeps, Superheroes, Demons, Dragons, Nerds, Dirts, Ghouls, Giants, Vampires, Zombies, and Other Curiosa

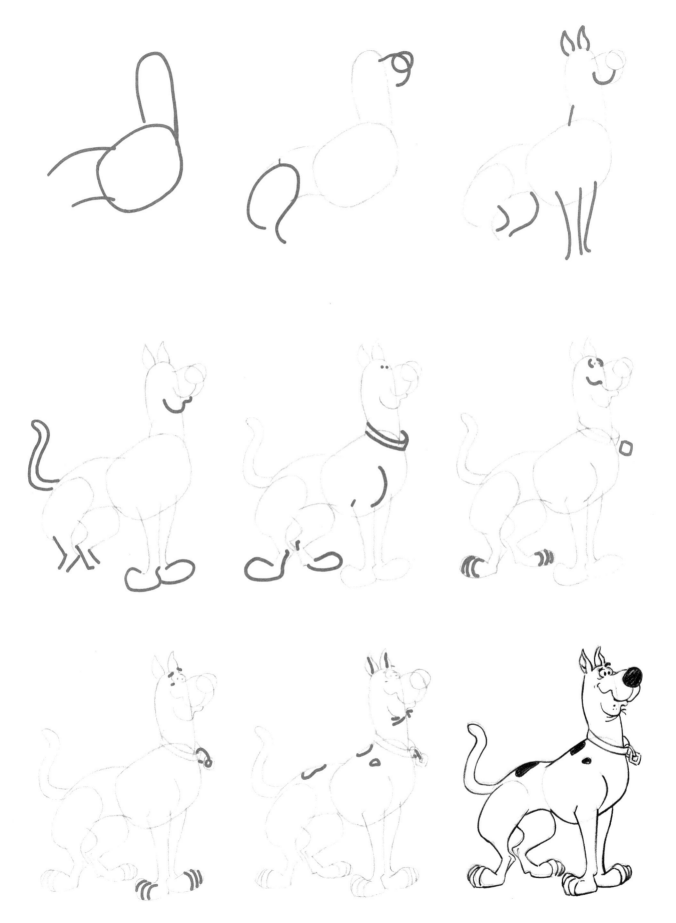

SCOOBY DOO
Draw 50 Famous Cartoons

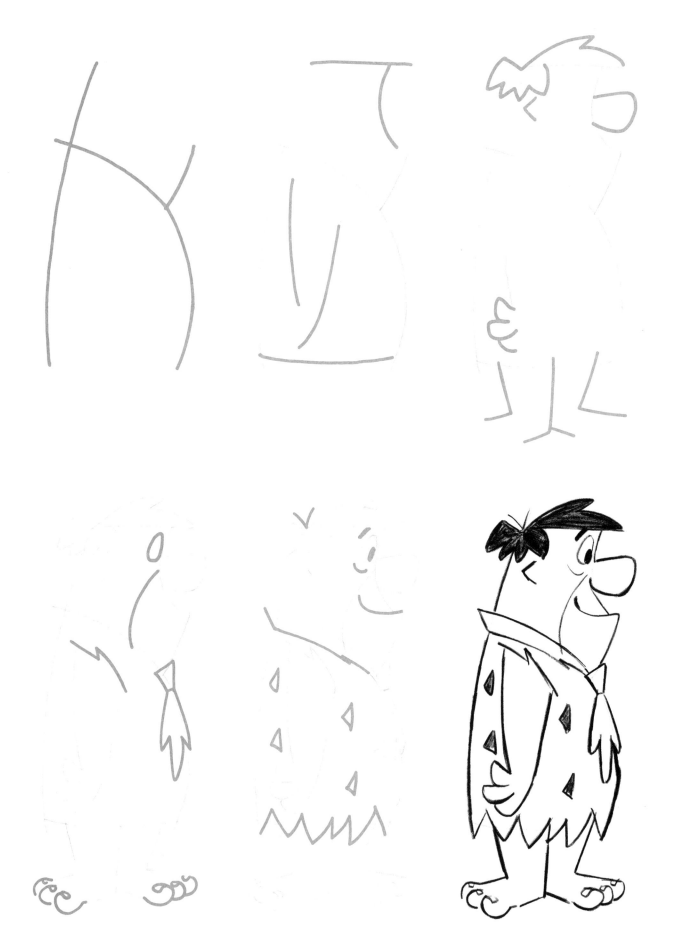

FRED FLINTSTONE
Draw 50 Famous Cartoons

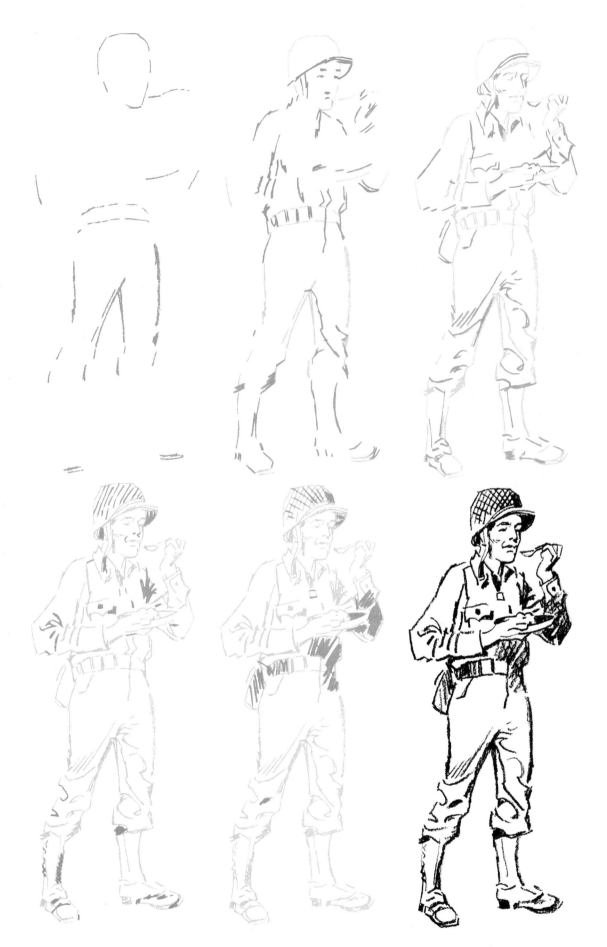

G.I. WWII
Draw 50 People

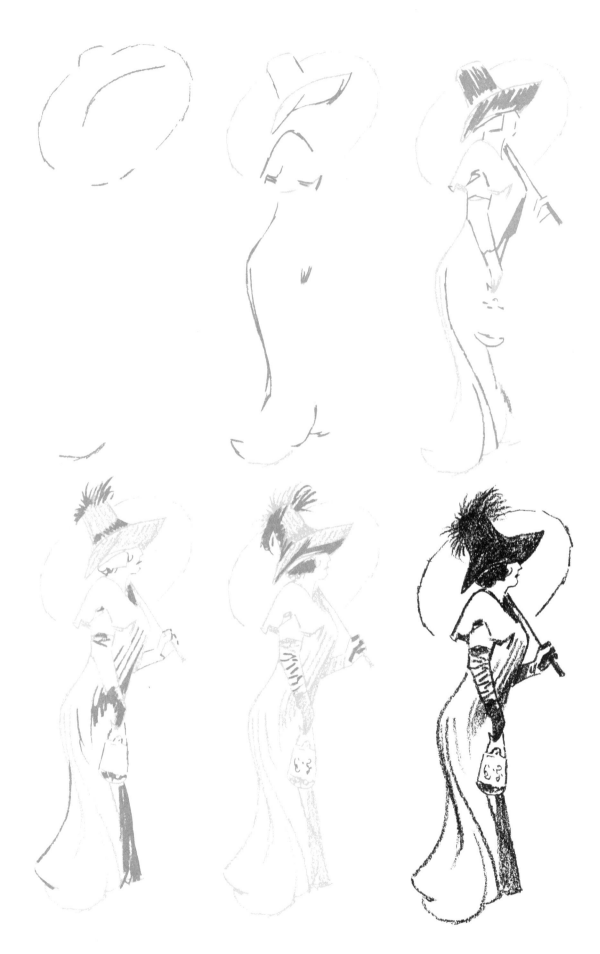

PARISIENNE

Draw 50 People

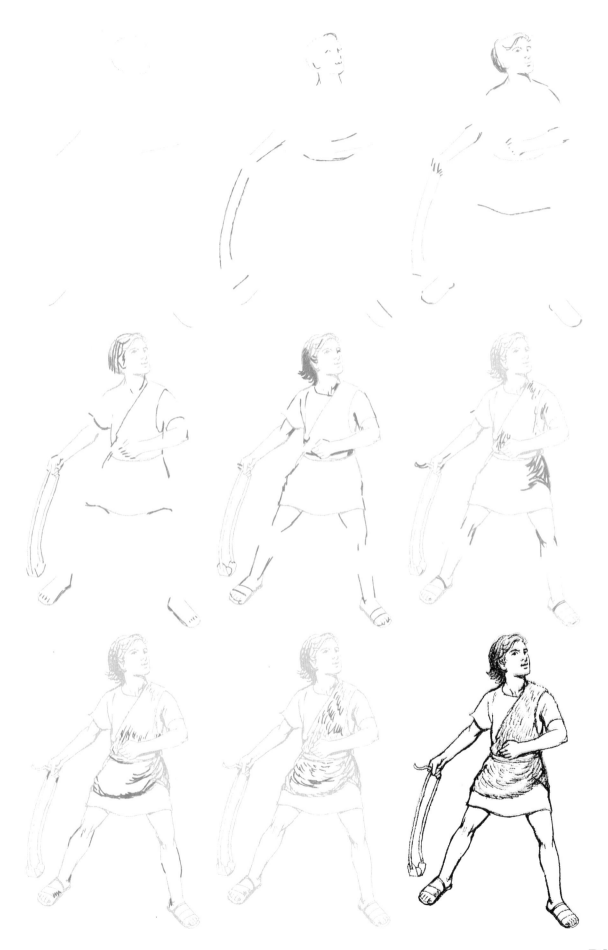

DAVID
Draw 50 People of the Bible

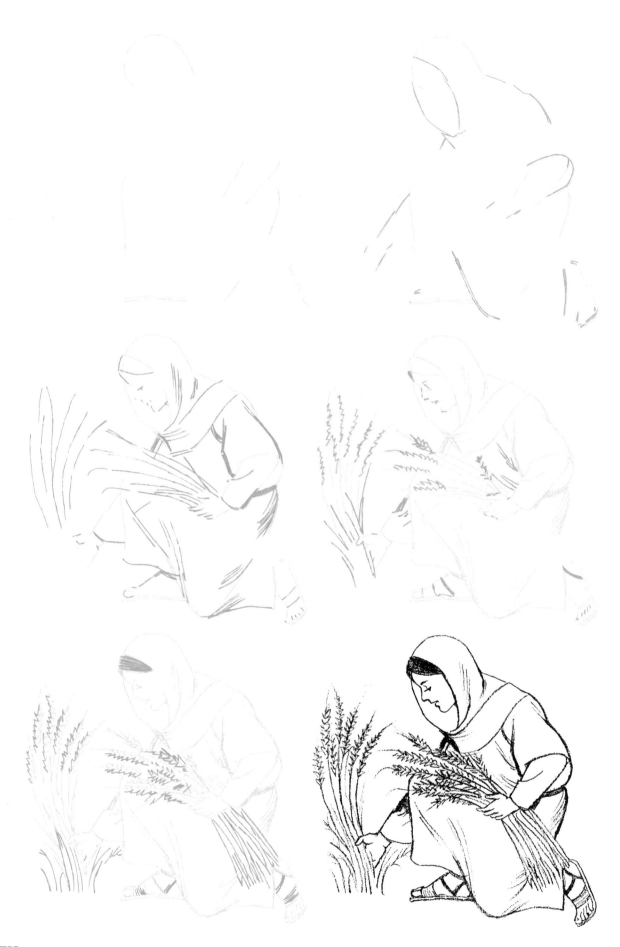

RUTH
Draw 50 People of the Bible

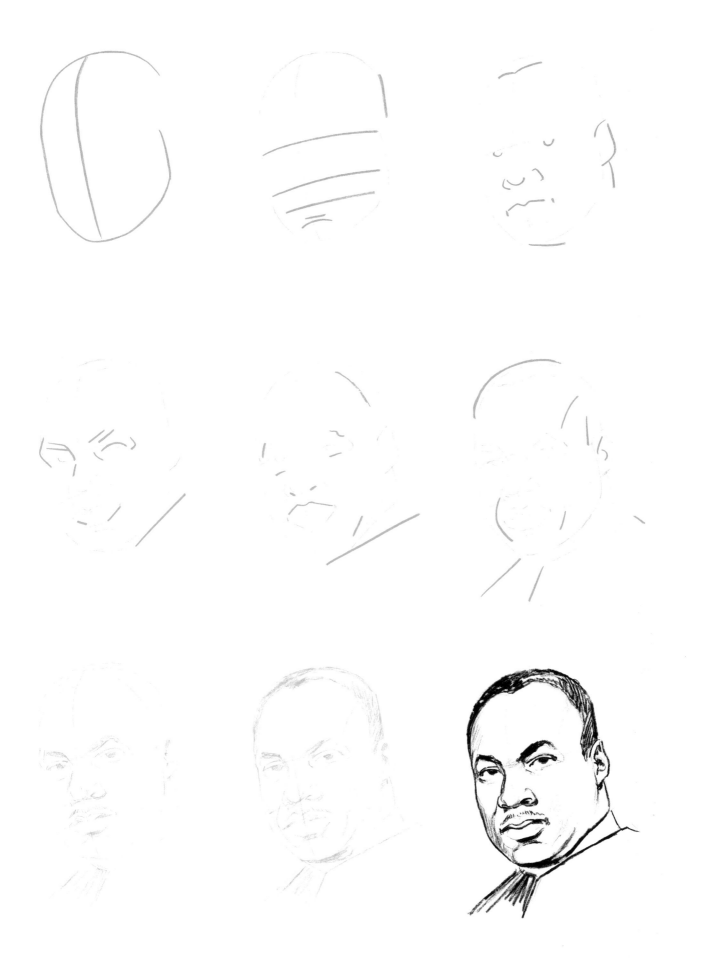

MARTIN LUTHER KING JR.
Draw 50 Famous Faces

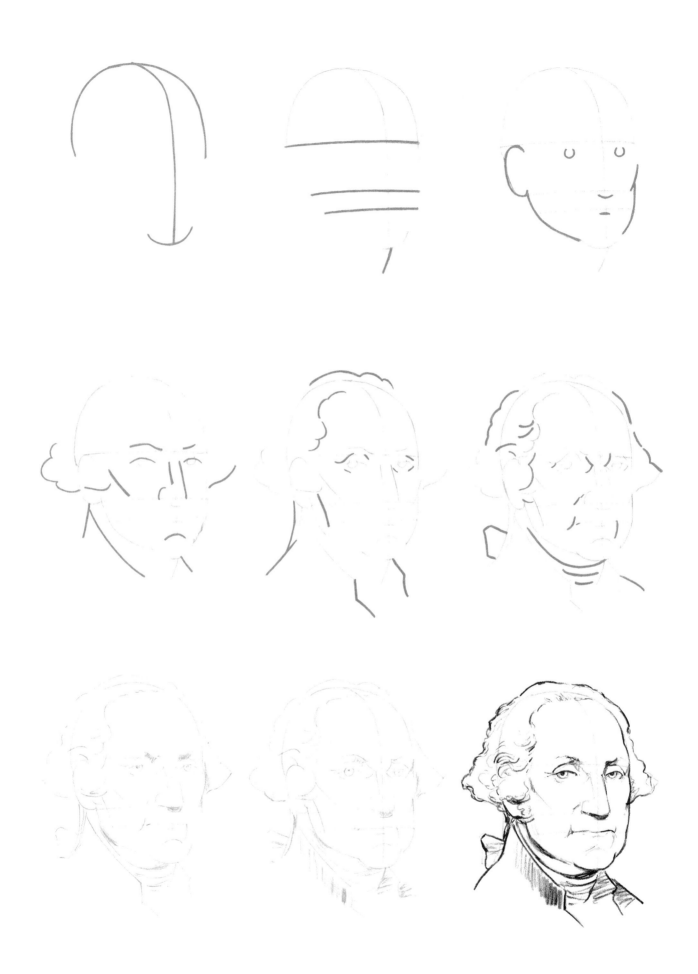

GEORGE WASHINGTON
Draw 50 Famous Faces

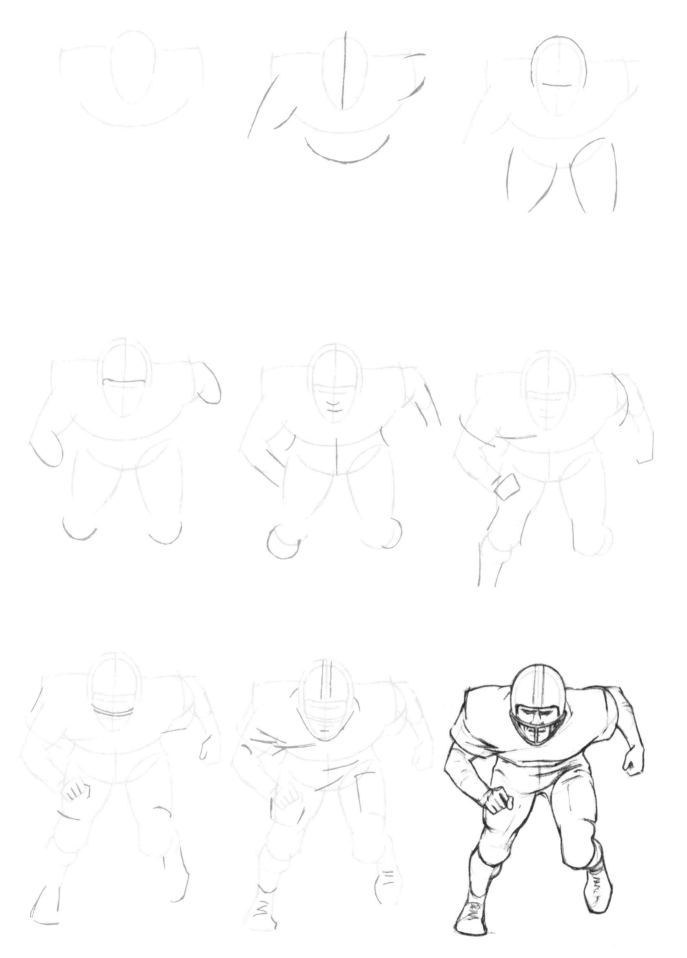

LINEBACKER
Draw 50 Athletes

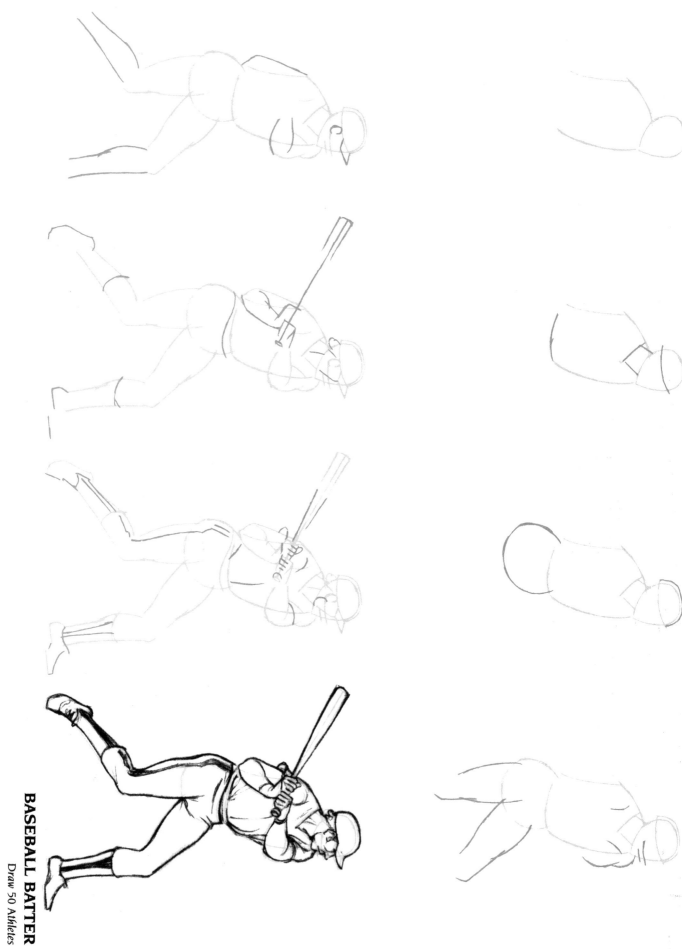

BASEBALL BATTER
Draw 50 Athletes

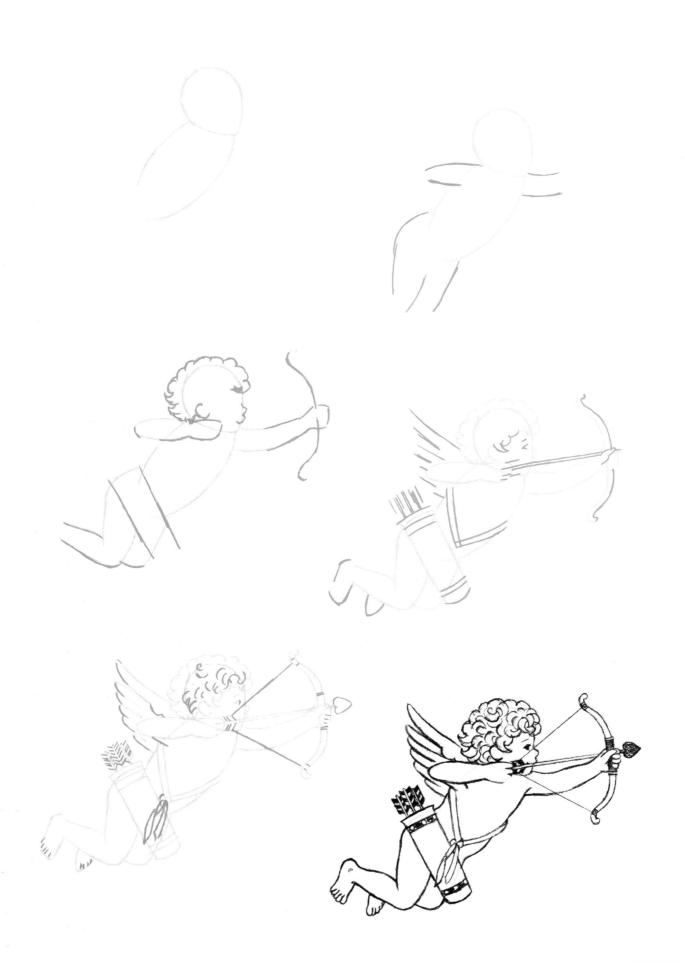

CUPID
Draw 50 Holiday Decorations

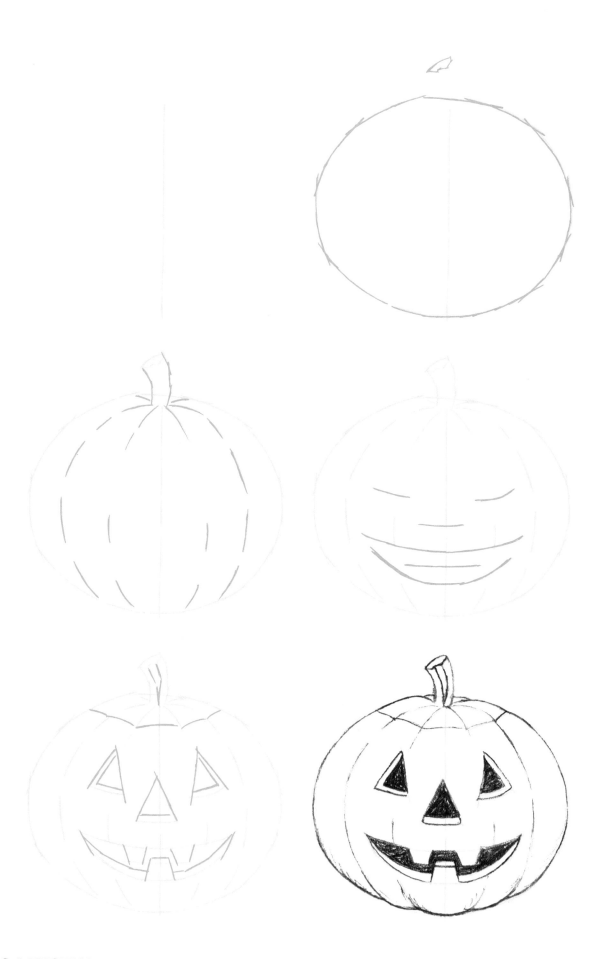

JACK-O-LANTERN

Draw 50 Holiday Decorations

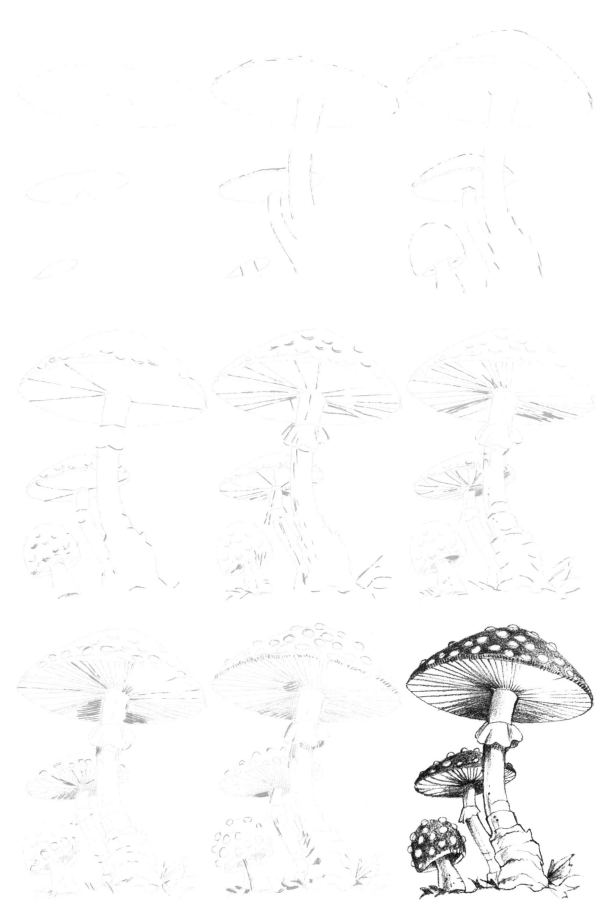

MUSHROOM

Draw 50 Flowers, Trees, and Other Plants

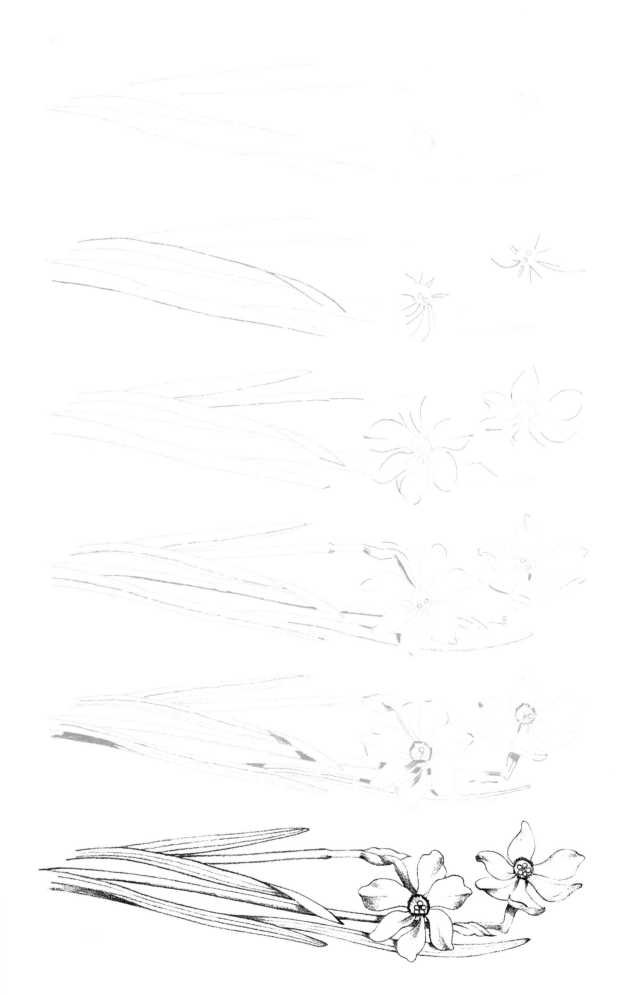

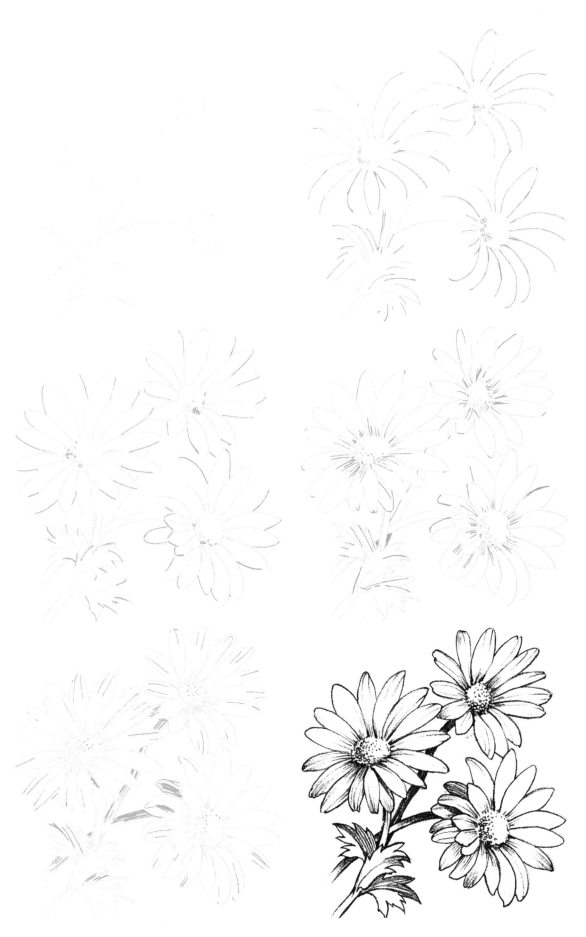

DAISY

Draw 50 Flowers, Trees, and Other Plants

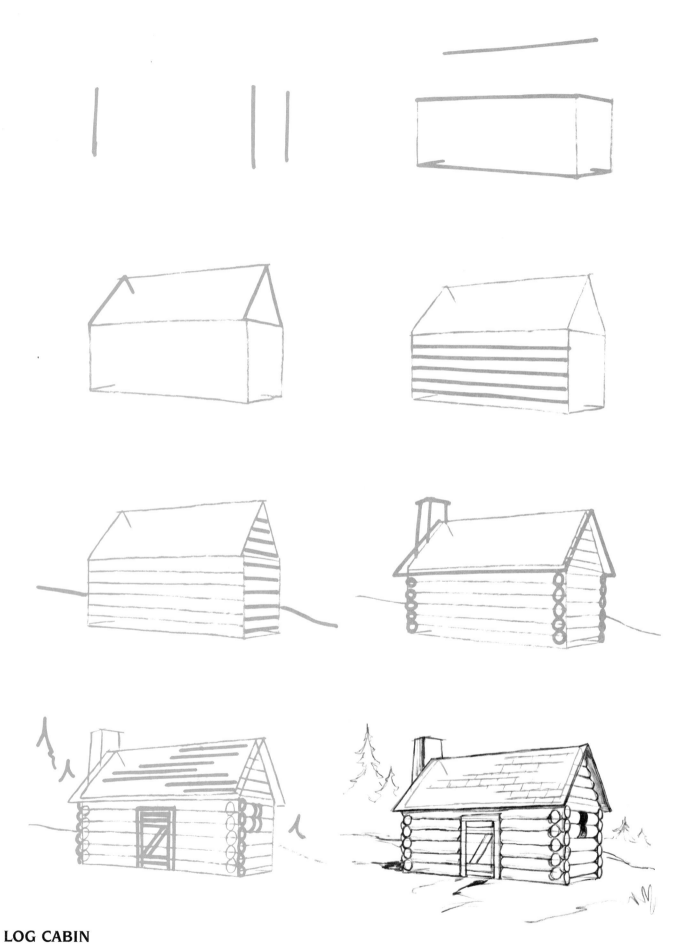

LOG CABIN

Draw 50 Buildings and Other Structures

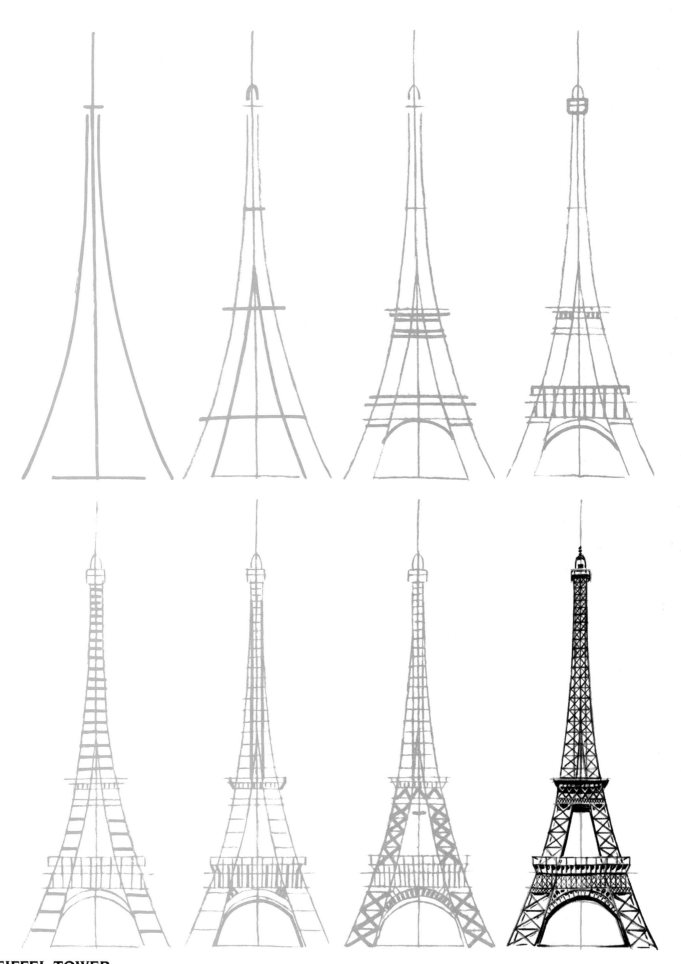

EIFFEL TOWER

Draw 50 Buildings and Other Structures

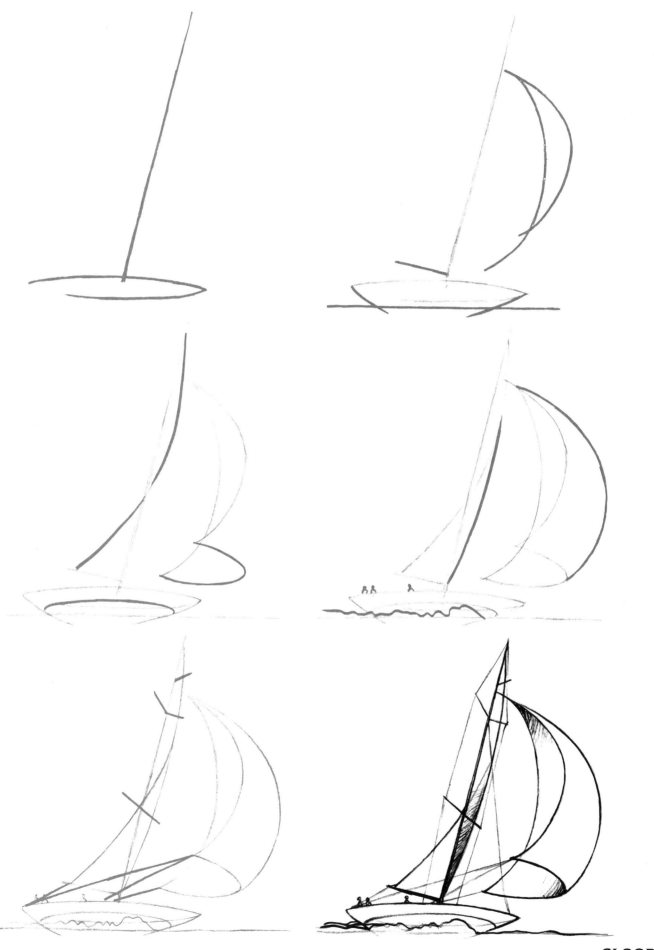

SLOOP
Draw 50 Vehicles

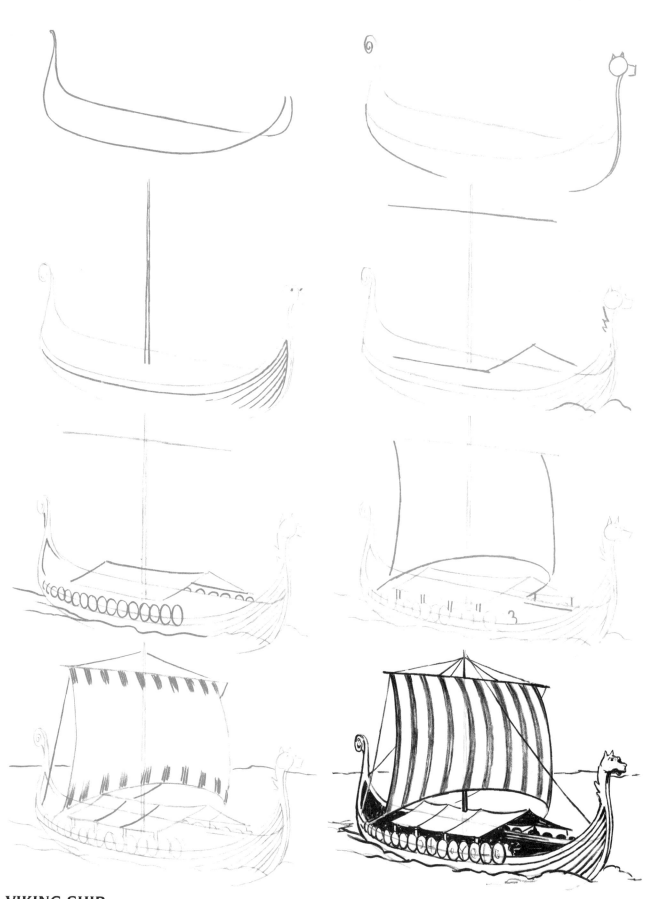

VIKING SHIP

Draw 50 Boats, Ships, Trucks, and Trains

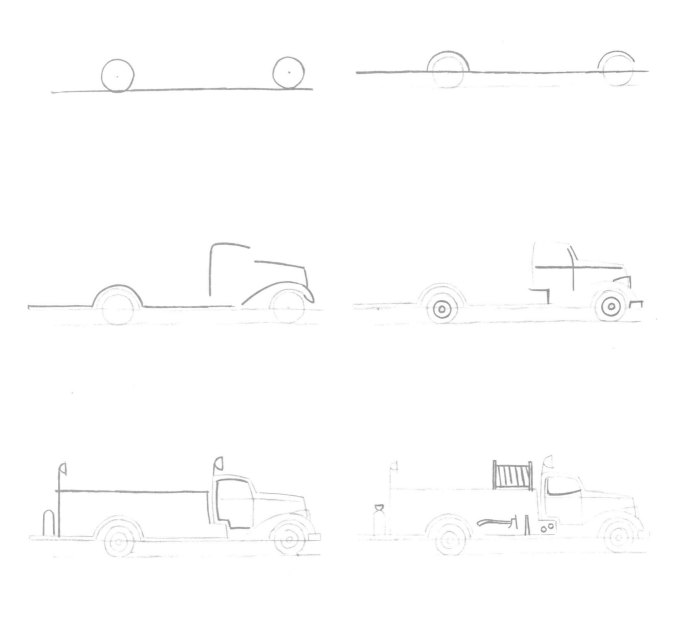

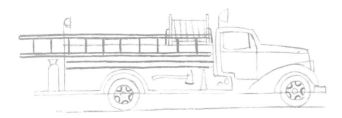

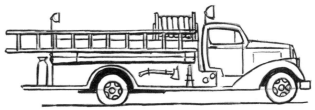

FIRETRUCK
Draw 50 Boats, Ships, Trucks, and Trains

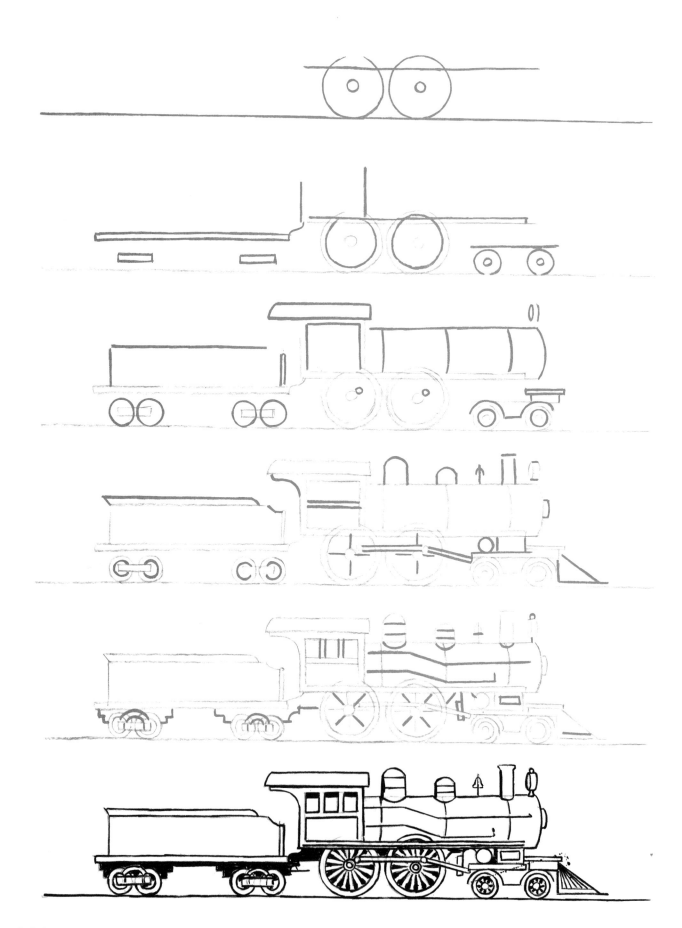

LOCOMOTIVE

Draw 50 Boats, Ships, Trucks, and Trains

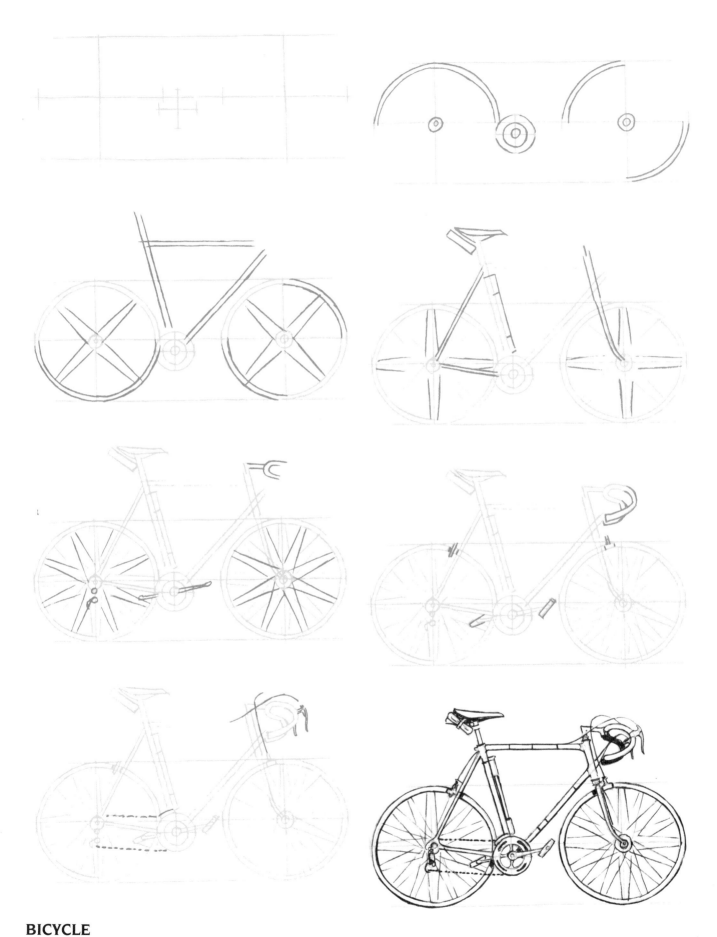

BICYCLE

Draw 50 Cars, Trucks, and Motorcycles

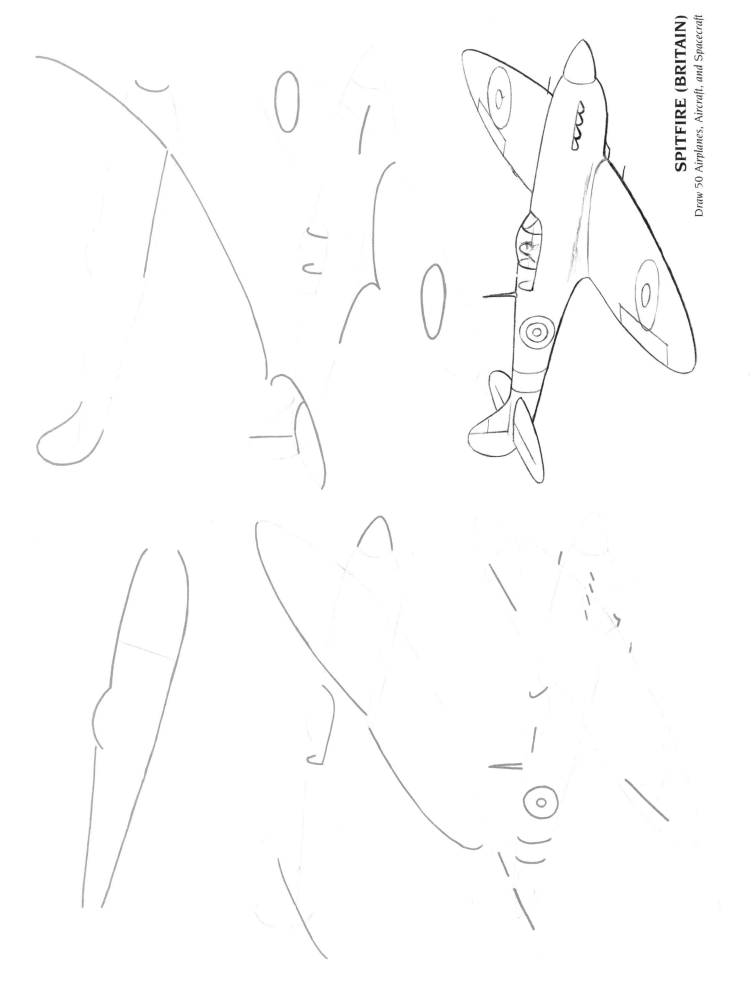

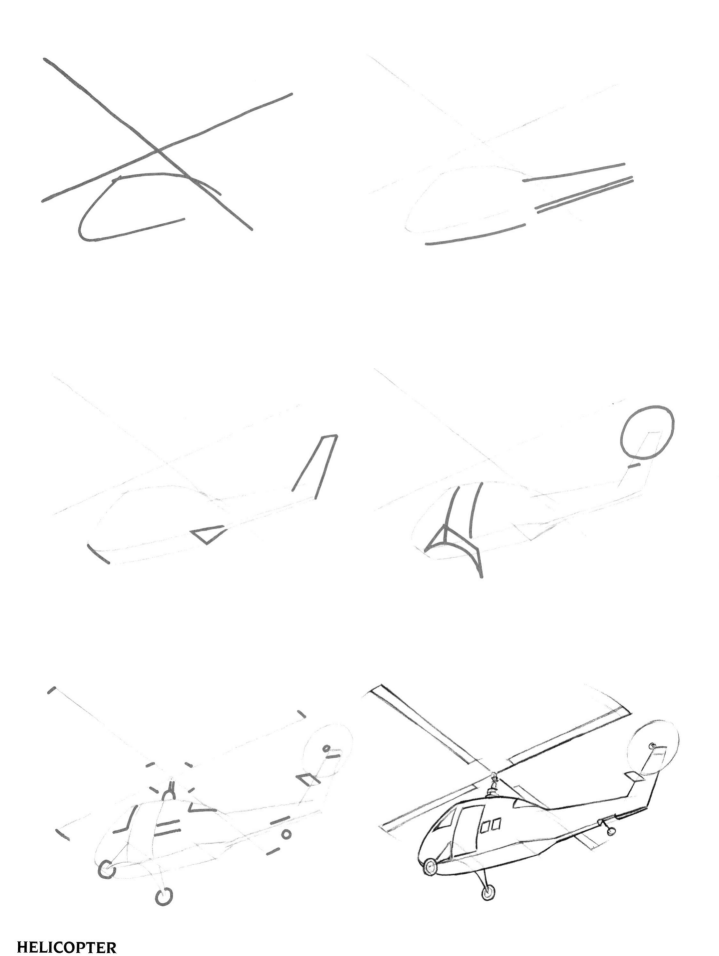

HELICOPTER

Draw 50 Airplanes, Aircraft, and Spacecraft

Lee J. Ames began his career at the Walt Disney Studios, working on films that included *Fantasia* and *Pinocchio*. He taught at the School of Visual Arts in Manhattan, and at Dowling College on Long Island, New York. An avid worker, Ames directed his own advertising agency, illustrated for several magazines, and illustrated approximately 150 books that range from picture books to postgraduate texts. He resided in Dix Hills, Long Island, with his wife, Jocelyn, until his death in June 2011.

DRAW THE DRAW 50 WAY

Experience All That the Draw 50 Series Has to Offer!

With this proven, step-by-step method, Lee J. Ames has taught millions how to draw everything from amphibians to automobiles. Now it's your turn! Pick up the pencil, get out some paper, and learn how to draw everything under the sun with the Draw 50 series.

Also Available:

- *Draw 50 Animal 'Toons*
- *Draw 50 Animals*
- *Draw 50 Athletes*
- *Draw 50 Baby Animals*
- *Draw 50 Cars, Trucks, and Motorcycles*
- *Draw 50 Cats*
- *Draw 50 Dinosaurs and Other Prehistoric Animals*
- *Draw 50 Dogs*
- *Draw 50 Famous Cartoons*
- *Draw 50 Flowers, Trees, and Other Plants*
- *Draw 50 Horses*
- *Draw 50 Monsters*
- *Draw 50 People*
- *Draw 50 Princesses*
- *Draw 50 Sharks, Whales, and Other Sea Creatures*
- *Draw 50 Vehicles*